ERIC LUKE
LOOKING BACK:
THE CHANGING FACES OF IRELAND

Born in Dalkey, south County Dublin, Eric Luke has always had a passion for photography. He joined the Irish Press Group as a staff photographer in 1973, following a brief stint working in the darkrooms as a photographic printer. Seventeen years later, in 1990, he moved to the *Irish Times*, covering major news and feature stories both at home and abroad, including two World Cups, five Olympic Games, and assignments in Somalia, Kenya, India, Sydney, Washington and London. However, his main focus lies at home in Ireland, adding to his personal collection of photographs, documenting the many changes in the Irish people and countryside. Eric has won numerous awards, including the World Press Photo News Award and PPAI Photographer of the Year, over a forty-year career in photojournalism.

ERIC LUKE

LOOKING BACK:

THE CHANGING FACES OF IRELAND

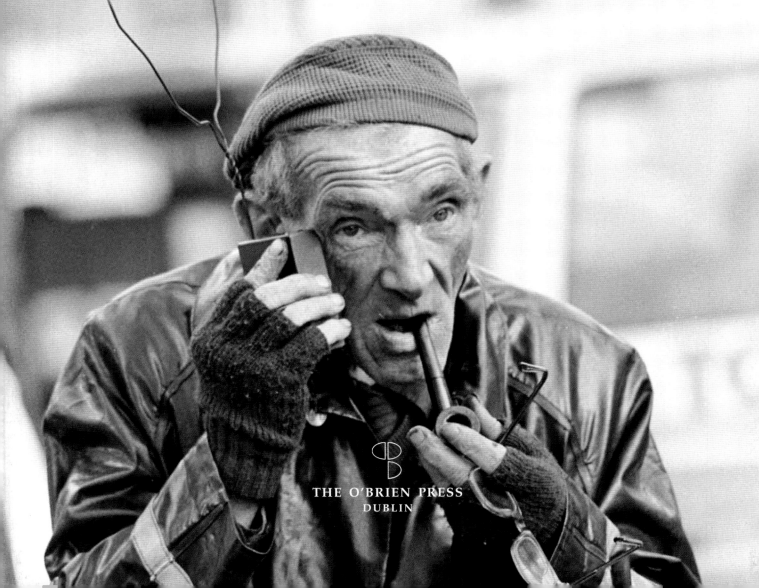

THE O'BRIEN PRESS
DUBLIN

First published 2016 by The O'Brien Press Ltd,
12 Terenure Road East, Rathgar, Dublin 6, D06 HD27, Ireland.
Tel: +353 1 4923333; Fax: +353 1 4922777
E-mail: books@obrien.ie
Website: www.obrien.ie

ISBN: 978-1-84717-865-7

10 9 8 7 6 5 4 3 2 1
21 20 19 18 17 16

Printed and bound in Poland by Białostockie Zakłady Graficzne S.A.

The paper in this book is produced using pulp from managed forests.

Acknowledgments:
I gratefully acknowledge the help and permission to use pictures from *The
Irish Times* from editor Kevin O'Sullivan.
I also wish to acknowledge the help of the people of Tory Island in
identifying and naming subjects of my old negatives.

Photo credits:
The Irish Times: pages 12, 25, 27, 30, 31, 34, 35, 56, 57, 58, 62, 63, 64, 68, 69
(top) , 71 (lower), 75, 76, 77, 83 (lower), 97, 126, 127, 132 (lower), 133, 134,
135, 137, 138, 139, 140, 141.
Eric Luke collection: pages 9, 11, 14, 16, 17, 18, 19, 20, 21, 22, 23, 26, 28, 29,
32, 33, 37, 38, 39, 40, 41, 42, 43, 44, 45, 46, 47, 48, 49, 50, 51, 52, 53, 54, 55,
59, 60, 61, 67, 70, 72, 73, 74, 78, 80, 81, 82, 83 (top), 84, 85, 86, 87, 88, 89,
90, 91, 92, 93, 94, 98, 100, 101, 102, 103, 104, 105, 106, 108, 109, 110, 111,
112, 113, 114, 115, 116, 117, 118, 120, 121, 122, 123, 124, 128, 129, 130, 131,
132 (top), 136.

Published in:

DUBLIN
UNESCO
City of Literature

DEDICATED TO YVONNE, JACK, AMY AND JENNIFER.

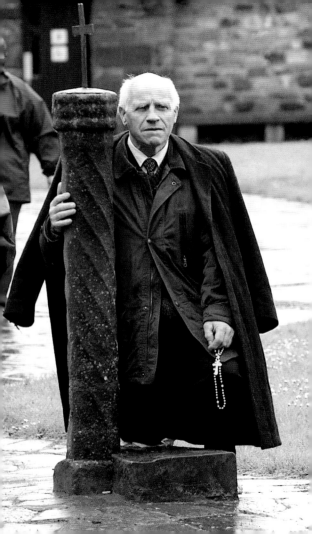

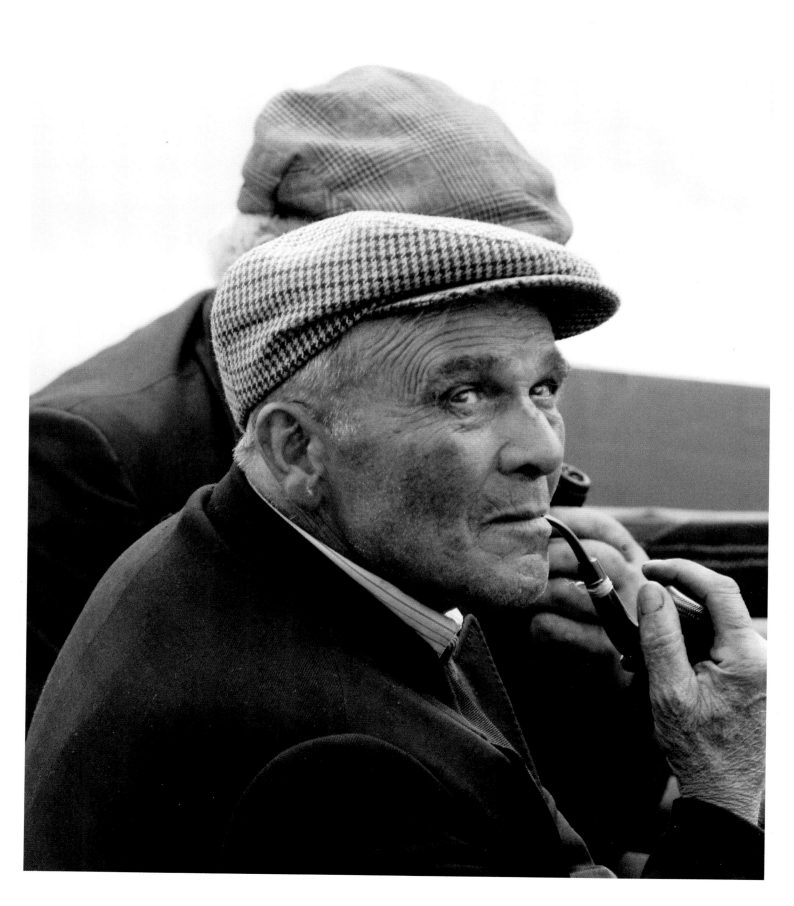

INTRODUCTION

It all started in Nancy in northern France, a couple of years ago. My daughter was there on an Erasmus programme, and I sat in the town square with an old film camera, producing yet more photographs to add to the growing mountain. I decided that the time had finally come to make some sort of sense of them, to impose order on my jumble of old negatives.

The idea of digging out and dusting down my old negatives at first seemed like a chore. But having retrieved numerous boxes of exposed sheets of 35mm film from a dusty and crowded attic, I soon warmed to the task.

Observing how my colleagues now engage with social media, I felt that twitter would be a good vehicle to present the pictures as I filed and organised. I began posting an old picture each day, and was surprised at the immediate and enthusiastic response. In an era of instant communication, this virtual exhibition of images was an old medium on a modern platform. It seemed to stir up nostalgia in people, and the pictures got a huge reaction. Little did I know that my old negatives would continue on their journey – from celluloid

in the attic to electronic social media, and then back full circle to a hardcover photographic book.

My photographic career started in 1973, when I joined the Irish Press group of newspapers, made up of the *Irish Press*, *Evening Press* and *Sunday Press*. The picture editor at the time was Liam Flynn, and he was responsible for all photographic content for the three titles. He was also in charge of the darkrooms and a skilled group of photographic printers. All three newspapers were known for great news coverage and excellent usage of pictures. As the three papers required coverage nationwide, photographers got the opportunity to visit most parts of the country.

In the 1970s, a press photographer learned his craft by serving time as a photographic printer in the darkrooms. In the old Irish Press building on Burgh Quay, Dublin, we had a number of dark-rooms, with numerous photographic printers handling the work of seventeen staff photographers. This work taught us a real respect for 35mm film, and also taught the reality of what it could and could not do. The experience gained in the darkroom served well in later life, and would be very useful when behind the camera.

A colleague, the great photographer Colman Doyle, encour-aged me to 'do your own thing', to use my extra time to cover assignments of my own choice. I would go to concerts and sports events, and throw pictures at the paper. After five months in the darkrooms, I got hired on the staff. Joining that group of experi-enced shooters was indeed a privilege. And so followed a career of over forty colourful years as staff photographer with Irish news-papers, during which I spent my spare time shooting pictures of personal interest.

This included many trips to Tory Island, and other islands off the west coast of Ireland; visits to fairs throughout the country; music events in Dublin; and quite a few hazardous trips to the North of Ireland with Colman Doyle during the seventies and eighties.

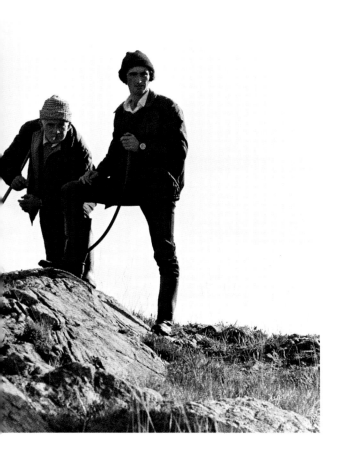

After seventeen years with the Irish Press, the time came to move on. I joined the *Irish Times* in 1990. The picture editor with the *Irish Times* was Dermot O'Shea, and he was wonderful to work with. I was sent on assignments to every corner of Ireland, and indeed on some exciting international stories, including five Olympic Games and two World Cups, the White House in Washington, Buckingham Palace and 10 Downing Street, and assignments in Somalia, Kenya and India. I would process films on location, scan the negatives, and transmit the images back to base.

It was all wonderful experience, and with a good picture editor I was assured of great usage of the pictures on my return. The tight ship that Dermot ran also included a group of expert darkroom technicians, ensuring top quality prints from the photographers' work. This combination of skills led to the *Irish Times'* deserved reputation for excellent photographic coverage.

One thing my photographic colleagues taught me was to try to use natural light where at all possible, even if it meant a loss in quality. Many of my early film exposures therefore involved pushing the film stock to the limit, with long development times and slow shutter speeds. Now, in a world of digital cameras with automatic focusing and exposure, this seems so bizarre. Perhaps pushing the limits of film and cameras worked in our favour, and helped capture the flavour of a past era.

There is an ongoing debate on the differences between digital and film photography. I like to think of them as two different forms of media – digital, with its forensic accuracy in reproducing a scene; and film, with its more atmospheric interpretation of the same scene. The 'noise' picked up on digital, versus the 'grain' on a roll of negative film. As ninety-five percent of this collection was shot on film, you can see where my loyalty lies.

The cameras employed for most of these pictures are light years removed from the cameras of today. Manual focus and manual exposure, on camera bodies without motor-drive – these things

all provide challenges and opportunities. The process involved first loading a roll of film, then measuring the light exposure on a separate exposure meter, and setting the shutter and aperture, then focusing on the subject and composing the shot. It's a wonder we ever succeeded in getting a picture at all.

There is also a certain discipline involved, when you are limited to thirty-six exposures on a roll of 35mm film. I find when shooting with my digital cameras today, I'm inclined to overshoot, as there is virtually no limit to the number of frames available. No fear of running out of film.

And so, having blown the cobwebs off those dusty old boxes of negatives from the last four decades, and put them in some kind of order, I noticed a sort of thread common to most – that people in their own environment, going about their daily lives, tell a story in themselves.

Most of these photographs have never appeared in any publication before, and it is a real pleasure for me to see them produced in book form. I hope you get pleasure from it too.

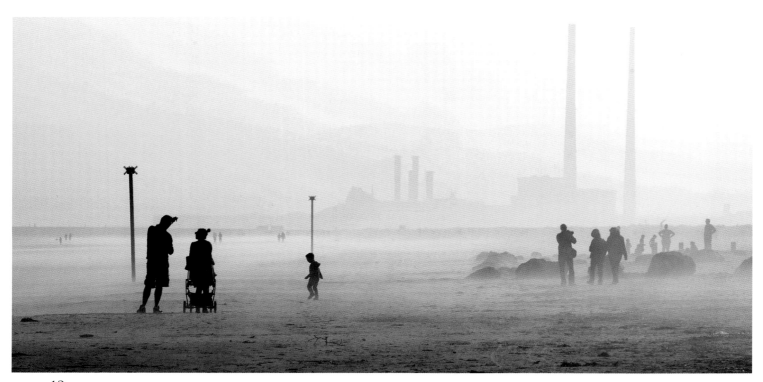

THE CAPITAL

I suppose Dublin is a good place to start, as it's where I started from, and it's also a fantastic place to take photographs.

In what other European capital city could you leave the office and, twenty minutes later, be photographing a fisherman in the bay? Dublin is surrounded by mountains, built on the River Liffey and edged with miles of beautiful beaches. Framed by these natural elements, opportunities for photographers pop up every day – whether images of the Dublin of old, gradually disappearing into the past, or of the modern, cosmopolitan city, home to people from many cultures and backgrounds. There are moments of tension, and moments of human connection, all available to be captured on film.

As the city becomes more modernised, it seems obvious, and I would say important, to record some of the older businesses and trades before they disappear. Businesses like Greer's saddlers and harness makers, and Dom McClure's barbershop, are being replaced by new concerns, and it is nice to be able to record them in some way before they are gone. We will not see their like again.

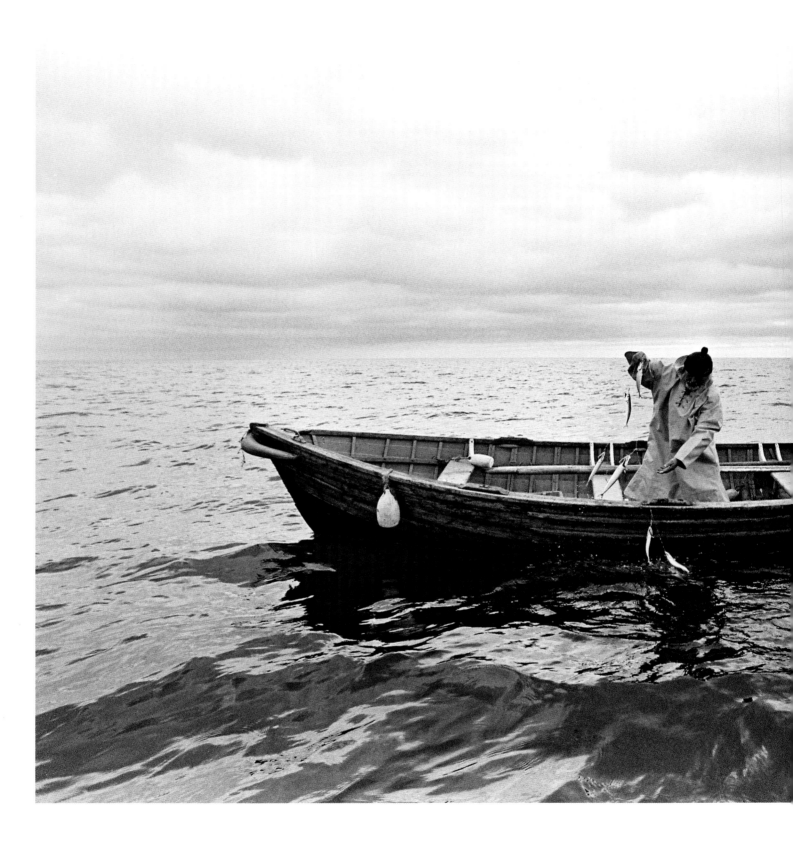

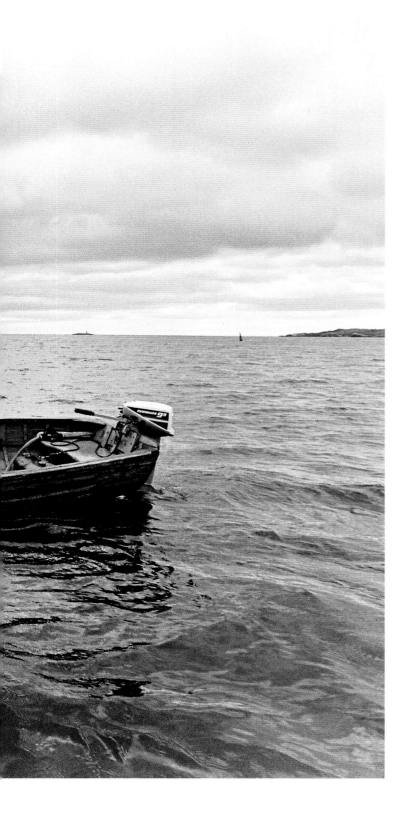

Joe Lawless, here pictured in 1985, fished for mackerel, lobster and crab for many years, from Bulloch Harbour, south County Dublin.

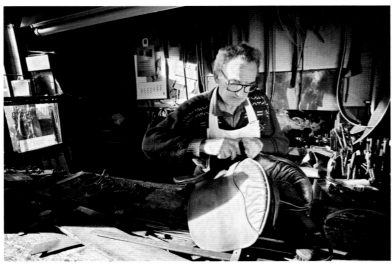

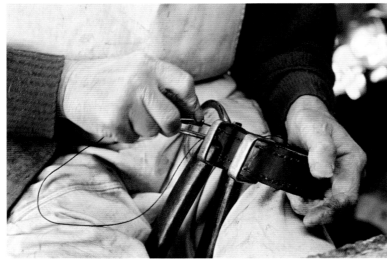

Right next door to our old Irish Press office on Poolbeg Street was the shop of Sam Greer, the last saddle and harness maker in Dublin. His grandfather, also Sam Greer, started the business in 1900. Horse owners from as far afield as the Aran Islands came to him for saddles, as the quality of his work was renowned. Greer's saddles are still highly valued for their hand stitching and fine craftsmanship. We would occasionally drop into him, and he would repair one of our leather camera bags, or make a new one from scratch if he had time. A Sam Greer camera bag would last much longer than the camera it held! On hearing he was closing down, I asked if I could spend his last day of business with him, photographing him for the record. He kindly let me spend the day with him, and I watched as he hand-crafted his wonderful leather goods. Then he closed up shop, and another old business disappeared from the city.

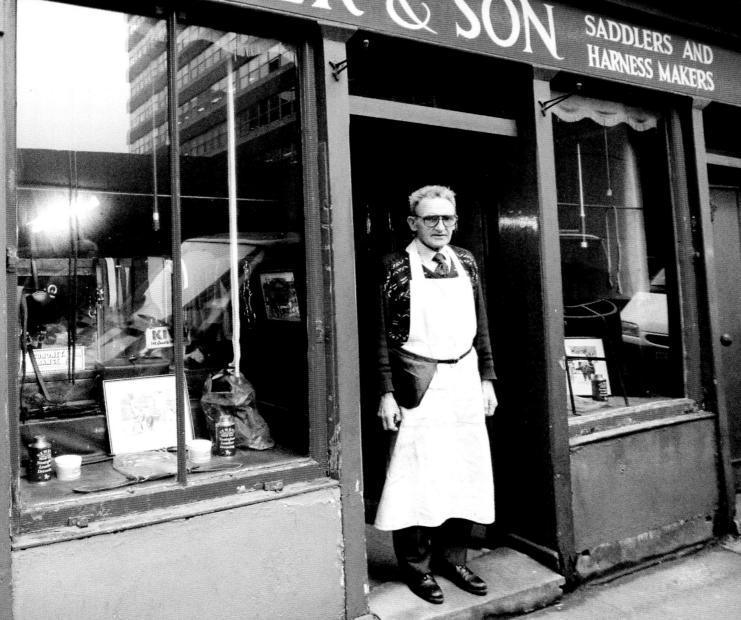

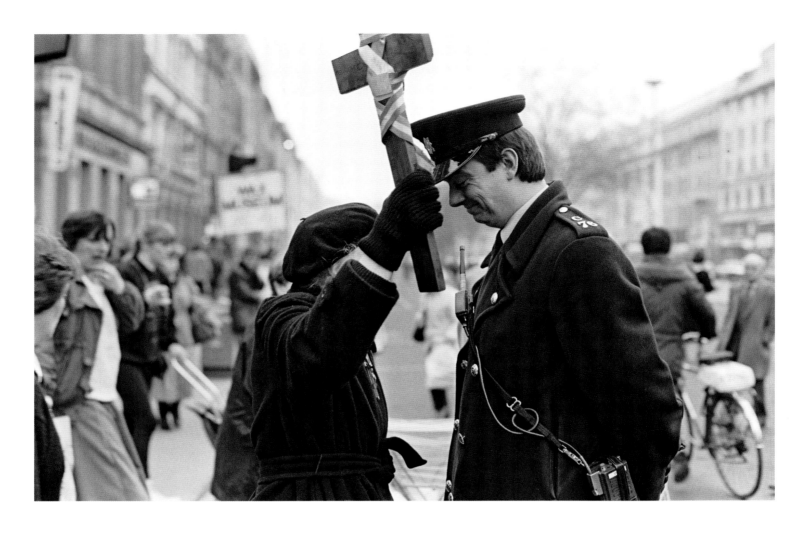

Street scene, O'Connell Street, 1980s. A Garda chats with a woman with a crucifix, a well known figure in Dublin city centre.

Traveller children and horse on a halting site in west Dublin, 1987.

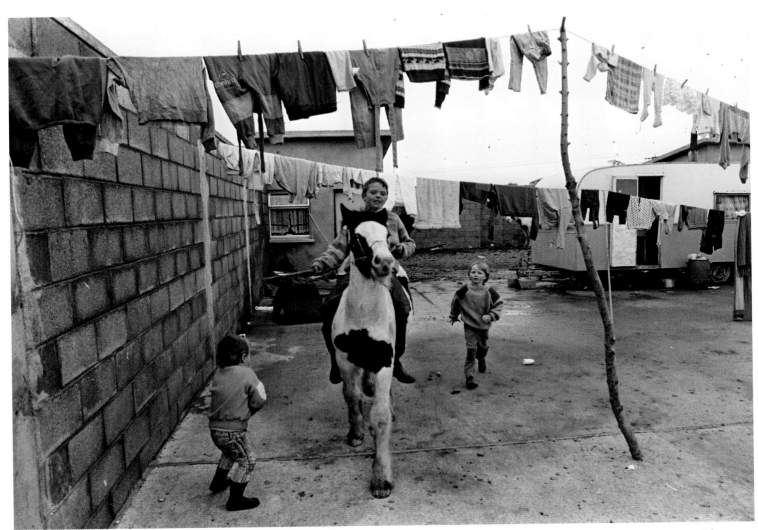

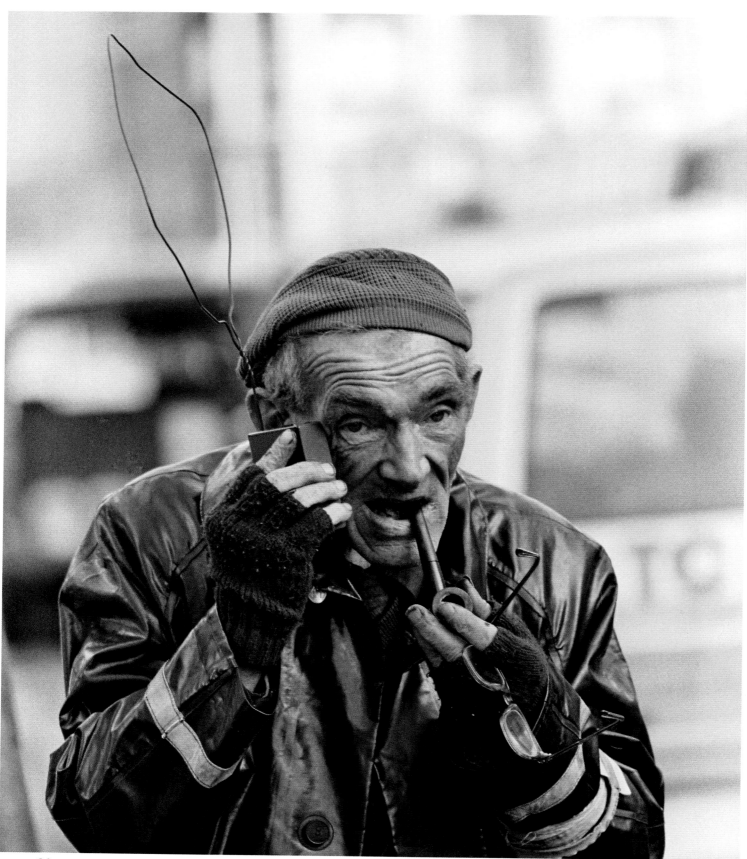

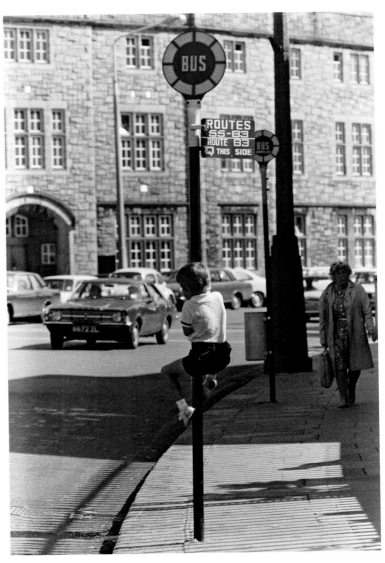

Opposite: Tuned in. This picture was taken on Westmoreland Street, just off O'Connell Bridge, in the late 1970s. I don't know if he was listening to a match, or to music, or to what, with his improvised antenna.

Right: A child observing the age-old tradition of climbing lampposts and bus stops, across the road from Pearse Street Garda Station, 1970s.

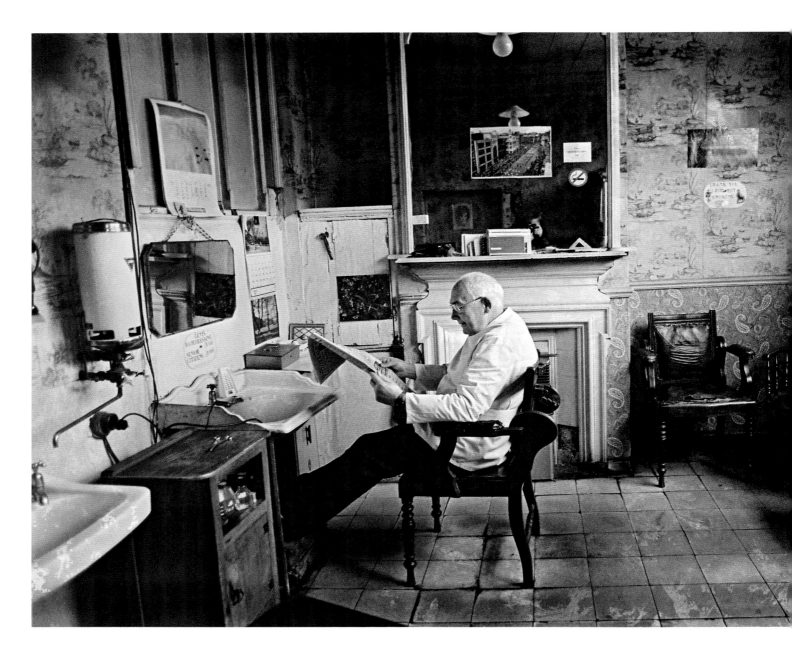

Another wonderful institution that is now long gone – the local barbershop, Dom McClure's in Castle Street, Dalkey. Growing up in the area, my mother would frog-march me to the barber's for a short back and sides. This meant a short journey to Pip Connolly's in Glasthule or McClure's in Dalkey. A plank would be set across the leather armrests of the solid wooden chair for a child to sit on. I never would have expected to be here thirty years later, photographing Dom before he closed up shop in the 1980s. This premises is still operating as a barber's, now under new ownership, and the great Pip Connolly still holds court in Glasthule.

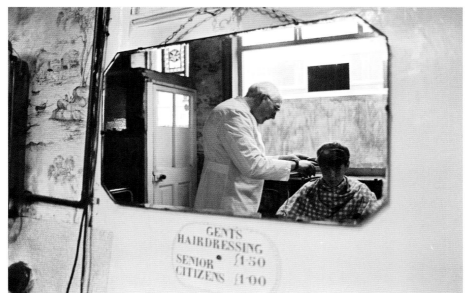

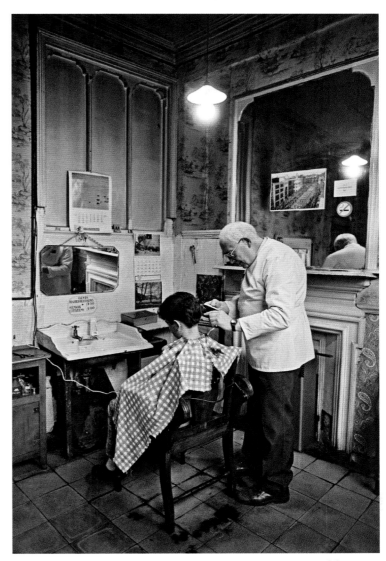

'An ill wind ...' It sounded like a simple, straightforward assignment – a hot, sunny day on Dollymount Strand. Visions of people sunbathing, swimming and eating ice cream, but it turned out far from that. It was late in the day when I arrived, after four o'clock in fact, and a thick fog had descended, blocking out all sunlight. The fog had not just blocked the sun, but appeared to remove almost all colour from the scene, replacing it with a surreal, misty landscape. While this is not the photograph I set out to take, it ended up a better, and much more interesting shot.

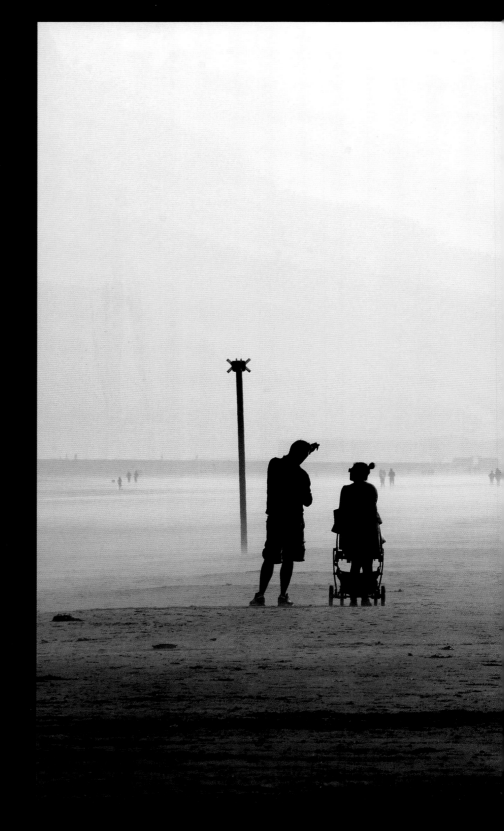

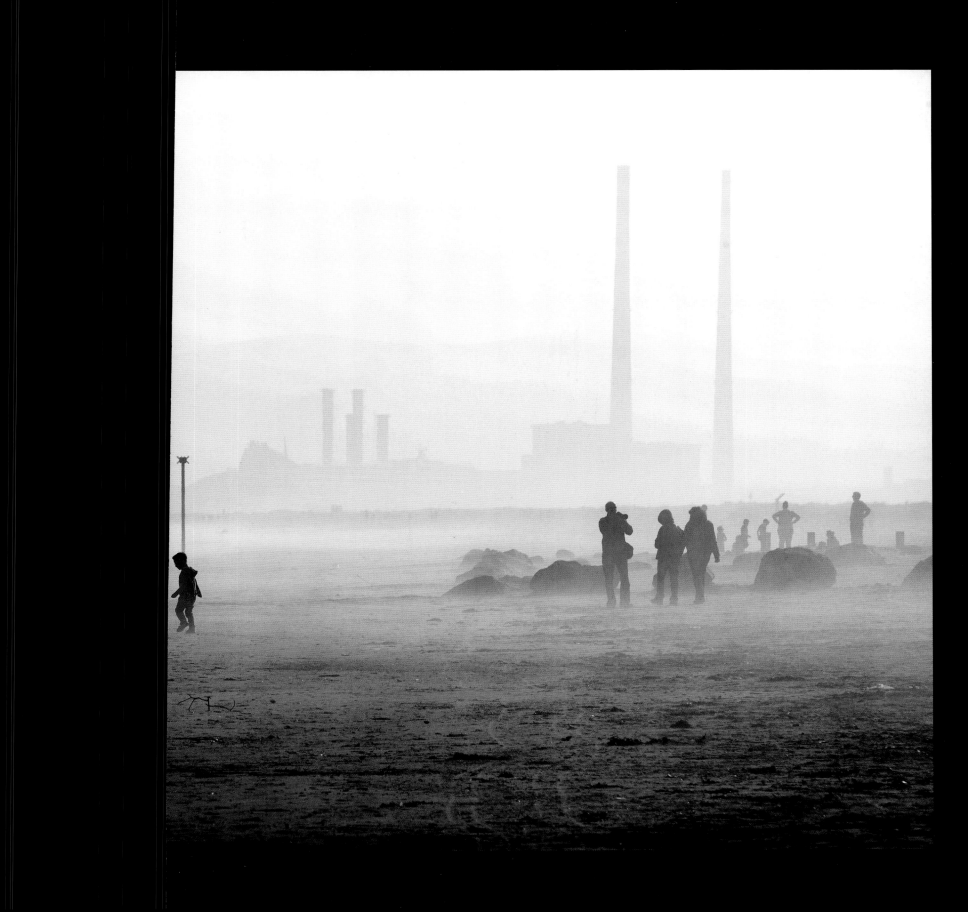

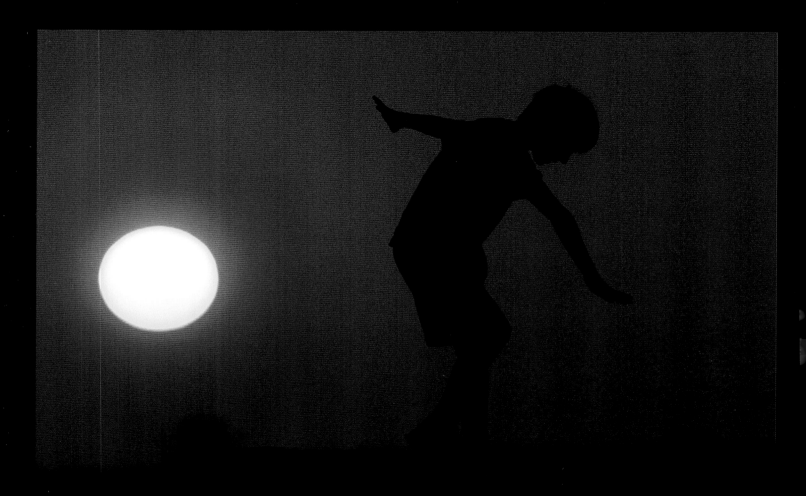

A glorious sunset on the longest day of the year – midsummer's day at Sandycove, south County Dublin. My young son Jack was playing on the rocks, oblivious to me taking pictures, providing a perfect silhouette against the sunset.

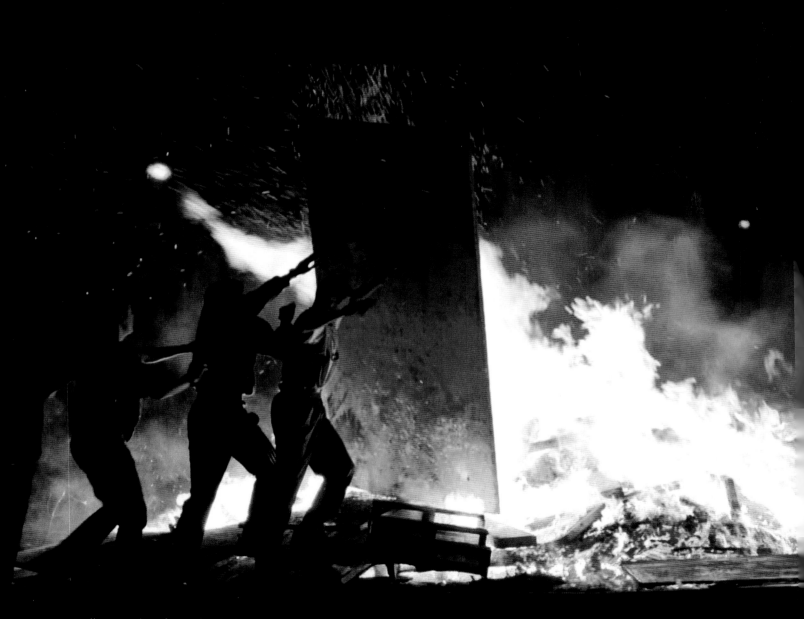

Halloween bonfire, Glasthule, County Dublin. I watched the materials
building up, day by day, as I drove past on my way to work. On Halloween
morning I stopped and asked some young fellas what time they would be
setting it alight, and came back in the evening to take shots.

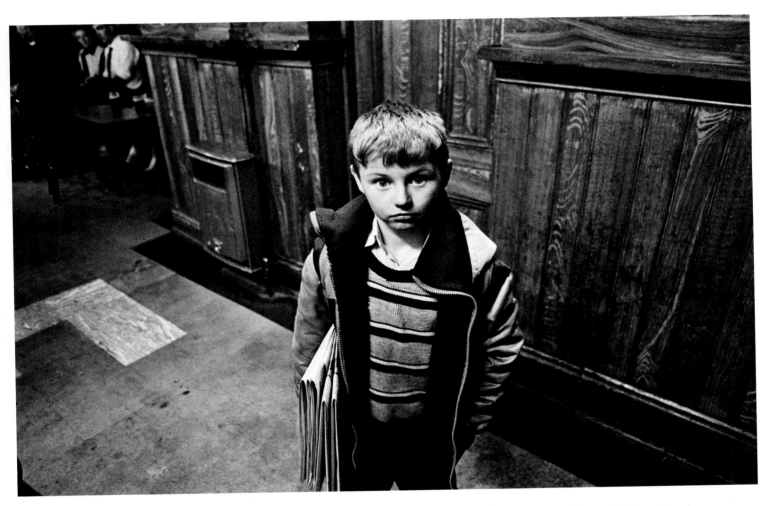

A young newspaper seller in Mulligan's pub,
Poolbeg Street.

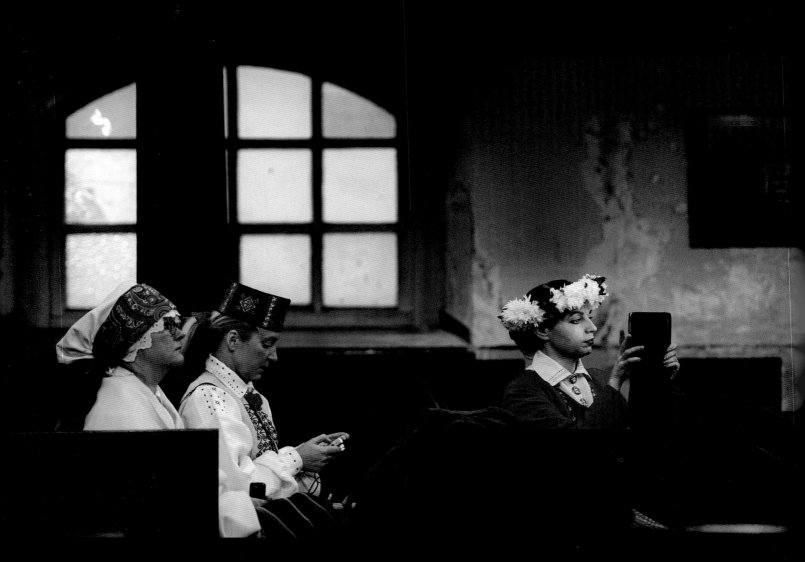

Anta Spunde, Maruta Kaire and Inguna Grietina, of the Latvian choir Elve, getting ready for the launch of Temple Bar Tradfest, in St Werburgh's Church in Dublin's Liberties area, 2013.

St Stephen's day always provides great opportunities to photograph 'wren boys', though they would usually be pictured outdoors. This crowd would go from pub to pub, reciting poetry and playing music, and the crowd would grow and grow. There could be fifty taking part, with maybe as many as thirty in costumes. This is during a poetry and song recital in a bar in Sandymount, 1999.

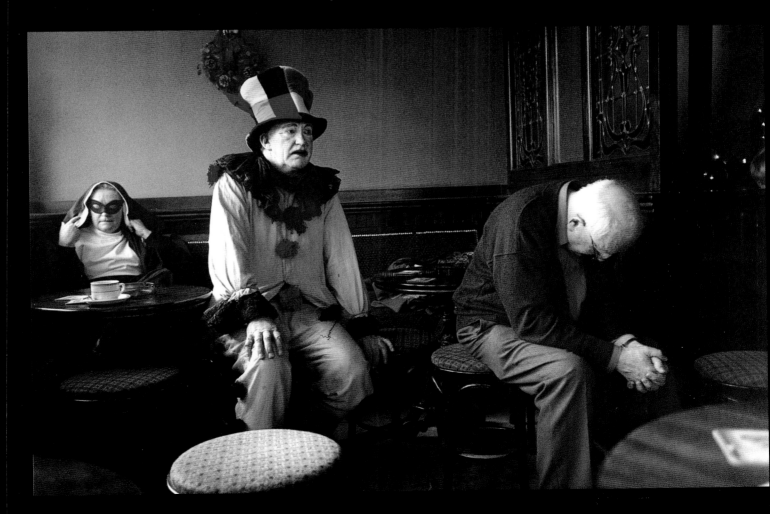

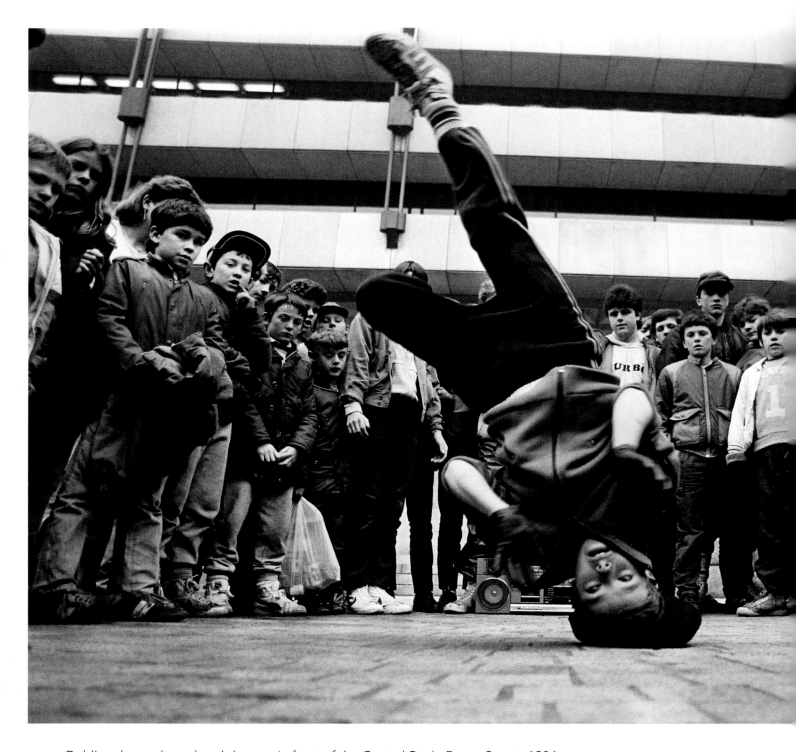

Dublin urban culture: breakdancers in front of the Central Bank, Dame Street, 1984.

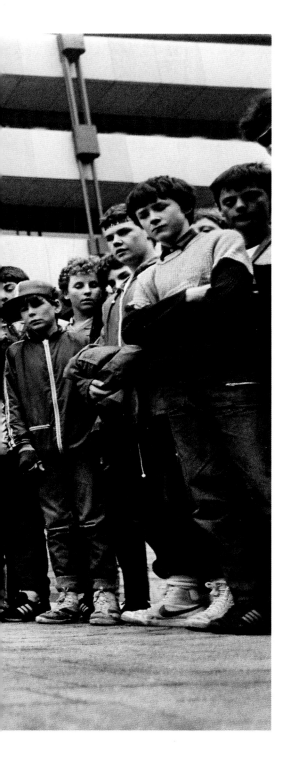

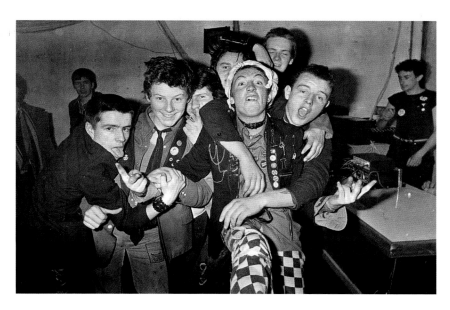

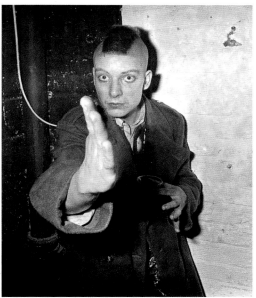

Punks in McGonagle's music venue,
South Anne Street, early 1980s.

A model shows off an early John Rocha design, at the Point Theatre (now the 3Arena), at North Wall Quay in Dublin's docklands.

Above: One of the students exhibiting at the annual Young Scientists Exhibition at the RDS, 1995.

Left: Meg (three) and Nanci (four) Creedon take a break by the pool, at a charity event in Dublin, 1990s.

THE COUNTRY

For someone born in Dublin, every opportunity has to be grabbed to head into the west, and for me this always meant the opportunity to photograph real people. You meet the most amazing characters travelling the byways of Ireland, engaged in all manner of interesting industry or just taking it handy and watching the world go by. From punters at a steam rally or a horse fair, to poitín makers and tinsmiths, from herding donkeys and milking cows to hunting and busking, it is all part of the daily business of life when you wander beyond the Pale.

When not on duty for the newspaper, I can work with a single 35mm film camera and a prime lens. The freedom is wonderful, and capturing images on this format is both unobtrusive and simple.

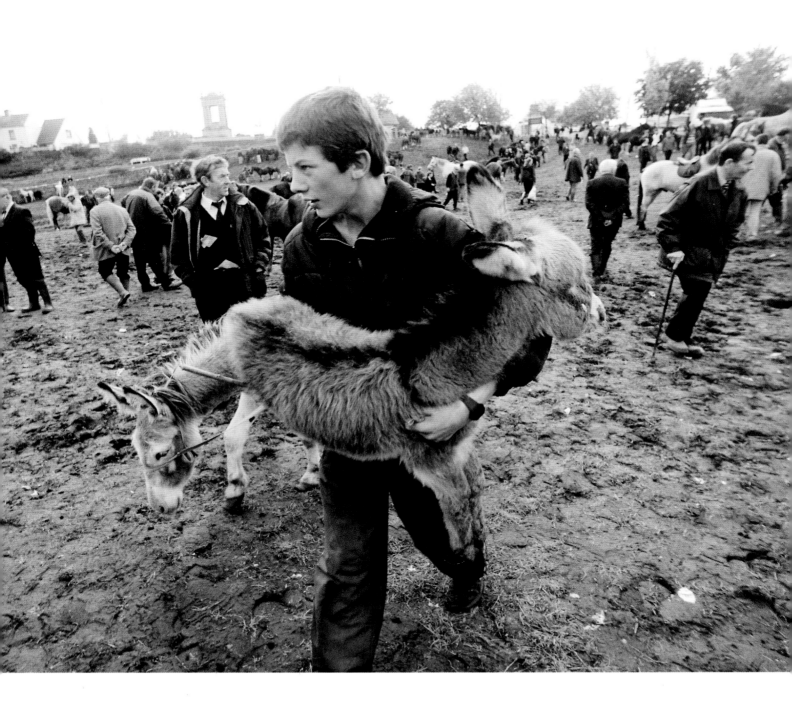

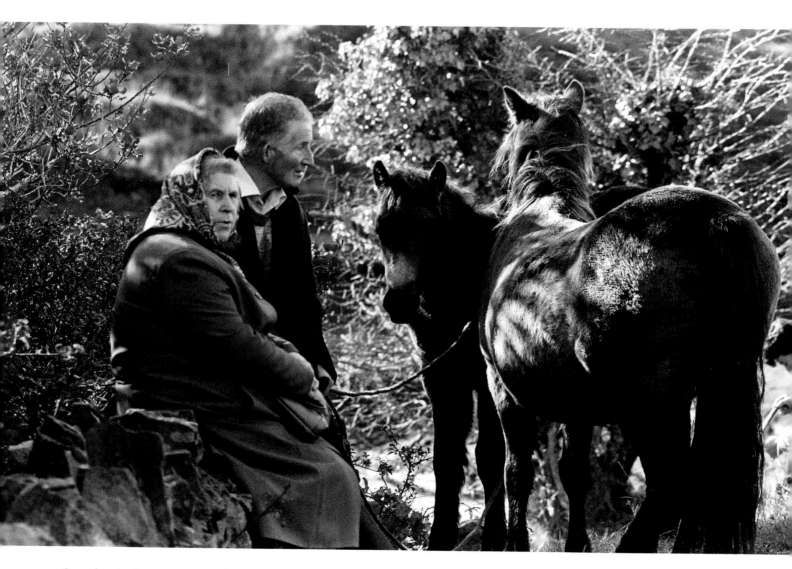

So, what is the attraction of the fair or market for photographers? People busy buying and selling have no time to be concerned with a photographer moving around and capturing images of the moment. While everyone's attention is on the livestock, the photographer can move around freely, shooting at will. Something that helps these old pictures is the style of dress of that time. Being able to shoot without high-viz jackets coming into the picture was a real bonus. A one-day horse fair at Maam Cross, Connemara, 1987.

Pages 36–37: Lending a hand to a four-legged friend.
Above: Taking a break in the sunshine.

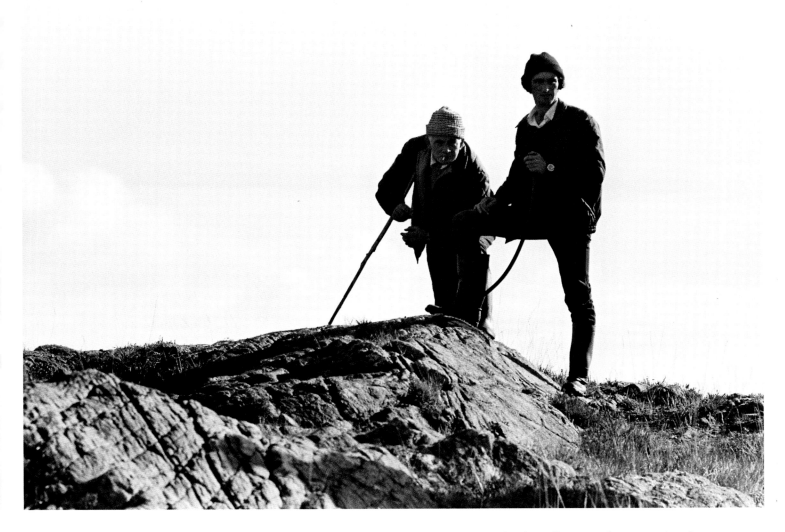

Above: Two punters at the fair silhouetted against the sky.

down to this every year, in early September. It's great, because
you don't run into too many other photographers.

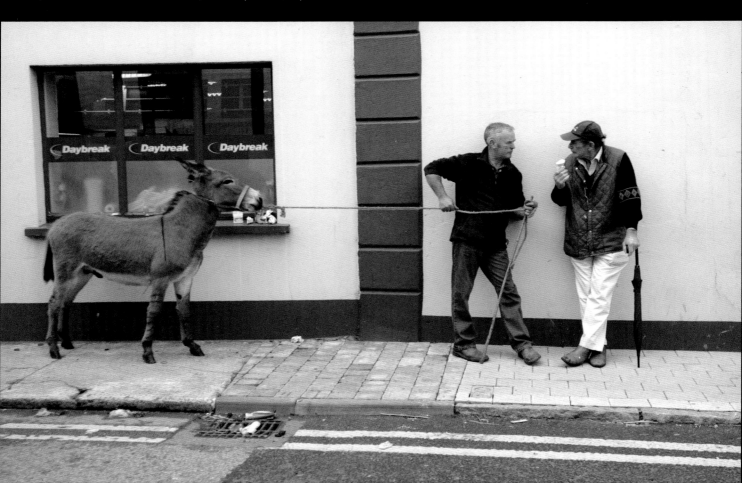

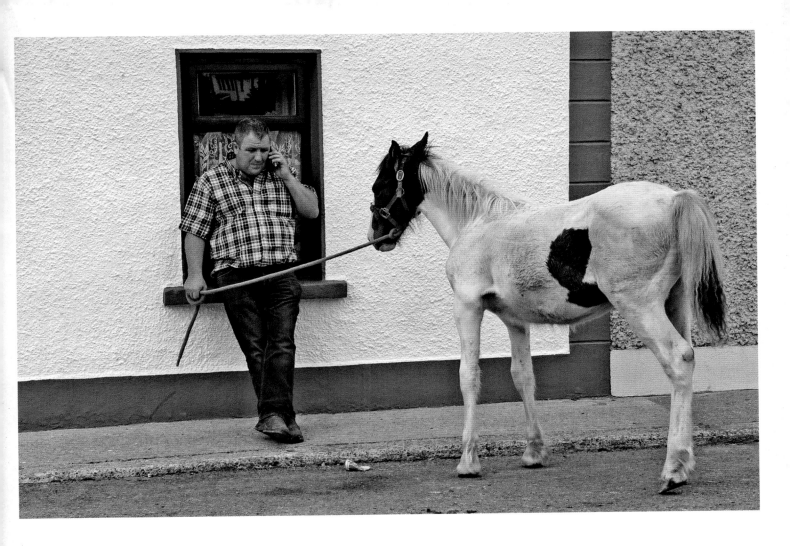

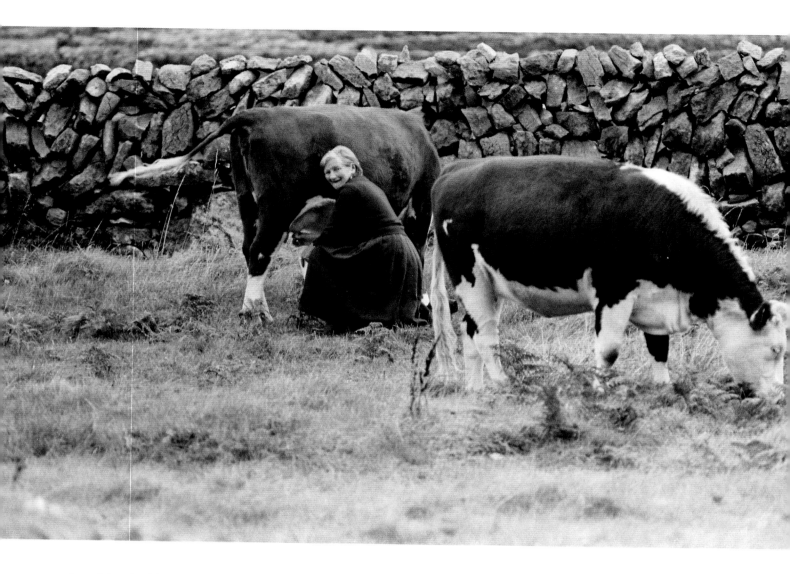

Aran Islands, 1970s. Preparing to milk a cow the traditional
way – out in a field, sitting on a three-legged stool.

Aran Islands. What I like is that he looks like he's cut from stone himself. You couldn't get any further from Dublin than this.

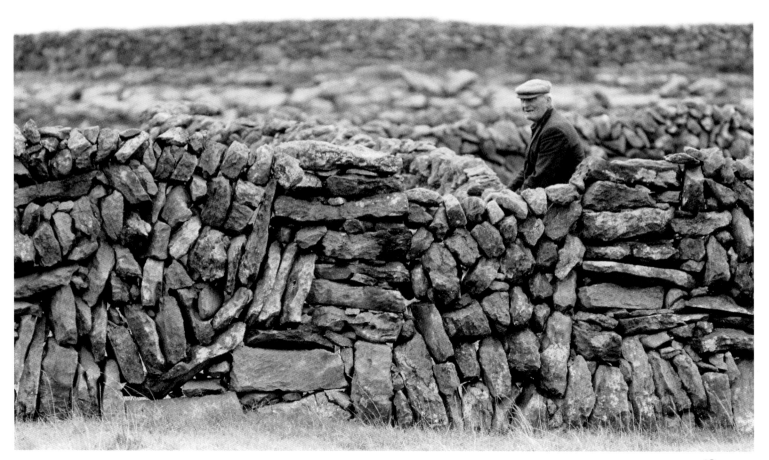

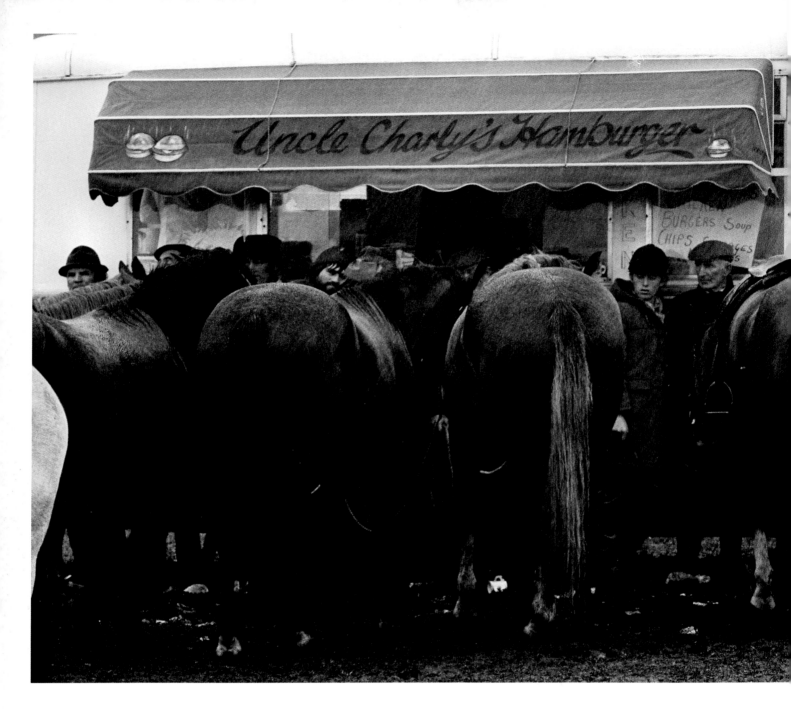

Ballinasloe horse fair, which stretches over two weekends, 1980. **Above:** Sheltering from a downpour of rain, along with the horses and everything. Note the interesting selection of headgear. **Opposite top:** Towing along some less willing participants. **Opposite bottom:** An overview of commercial goings-on at the fair.

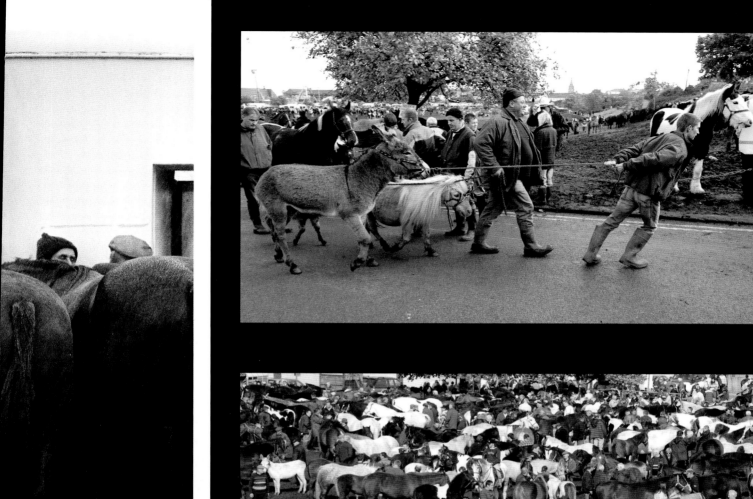

A regular sight on the Aran Islands – a herd of donkeys being driven
along the strand at low tide, 1977.

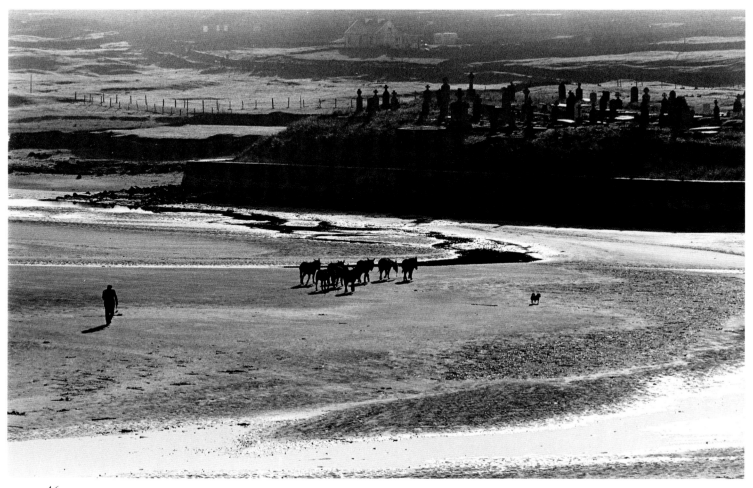

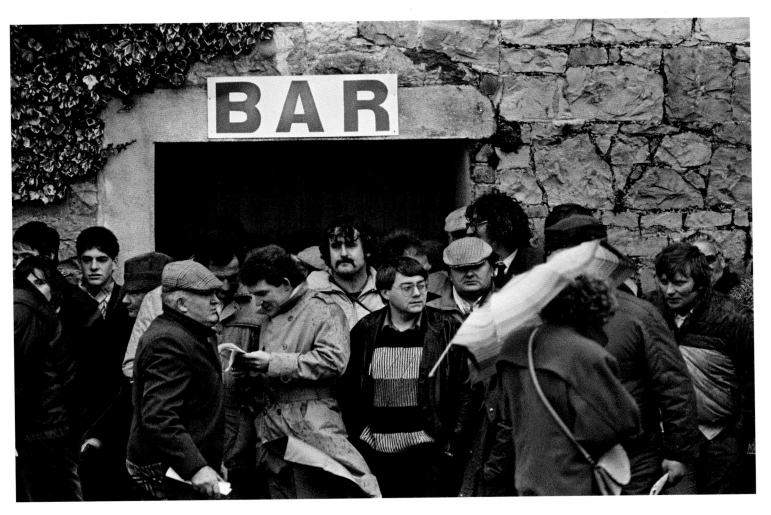

Limerick Races, St Stephen's Day, 1984. Part of the popularity of Christmas race meetings is that in some instances it can be the only place you can get a drink on St Stephen's Day.

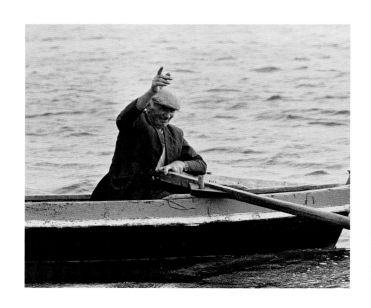

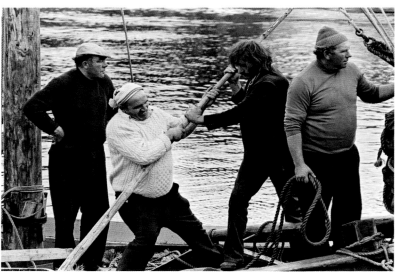

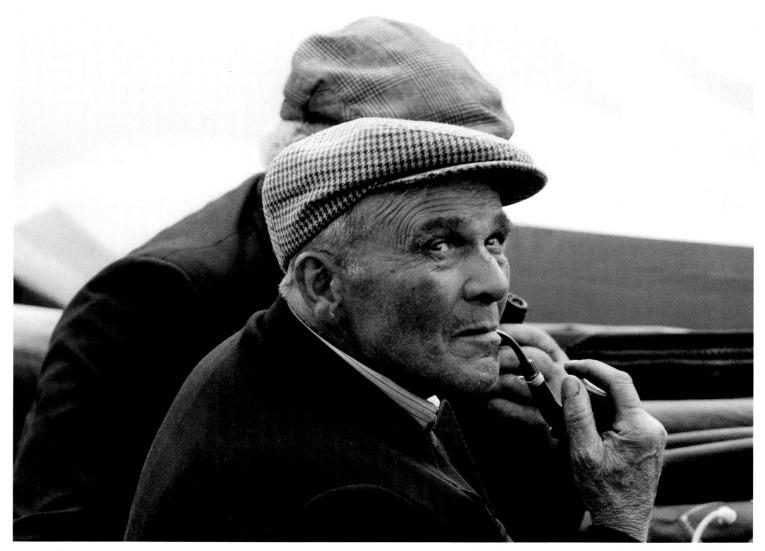

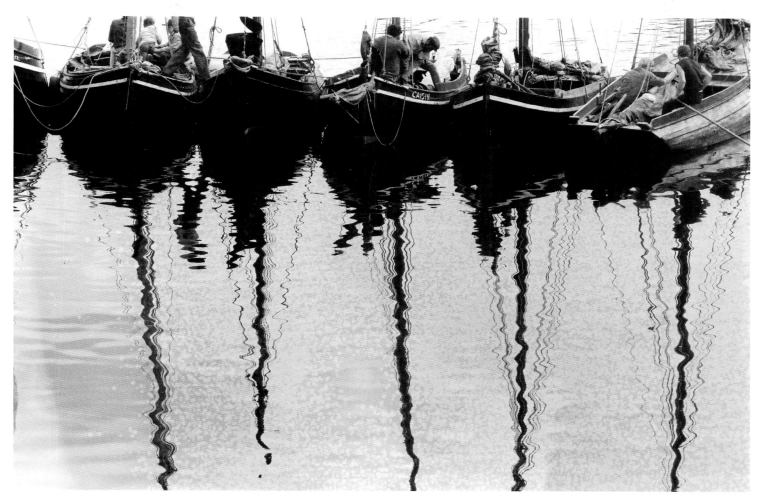

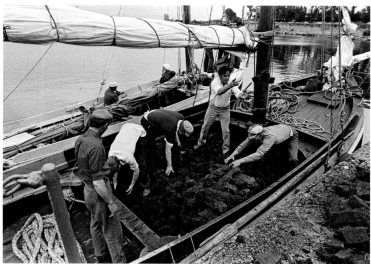

In August 1979, I attended the first Cruinniú na mBád. This annual event in Kinvara, County Galway, commemorates the role of the traditional wooden sailing boat, the Galway hooker. Built to withstand the heavy seas off the west of Ireland, one of the hooker's most important jobs was to carry loads of turf across Galway Bay from Connemara to Kinvara, where there is no turf. The event includes currach and hooker races, in a marvellous celebration of these great old cargo boats.

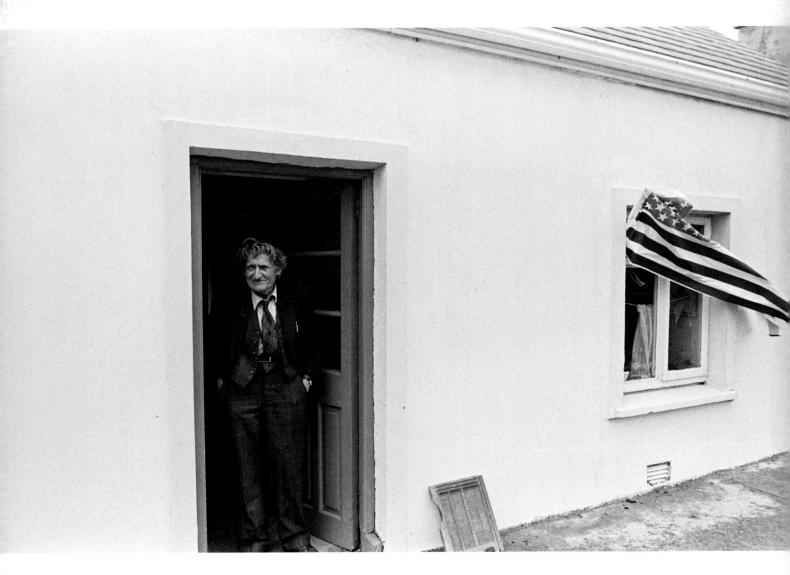

A Donegal man flies the stars and stripes from his cottage.

I asked a friend of mine if he could arrange for me to photograph some people making poitín, an old Irish tradition that is, understandably, rarely photographed. This was in late 1979, and there would have been a big pre-Christmas rush in the market for the spirit, which is drunk fresh from the still. I was picked up and brought to a very remote spot, where the men were just finishing their clandestine operation. They allowed me to take some shots before hurriedly dismantling their equipment, for fear of being caught and having their gear confiscated. It clearly took a lot of gas bottles to power the still, which would have to be heated for several hours. I'm so glad, looking back, that I shot these images on colour transparency.

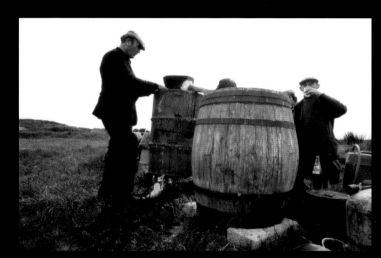

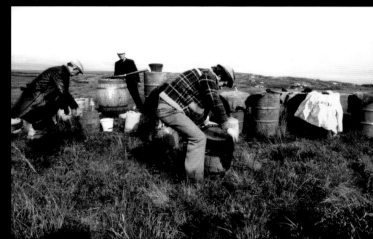

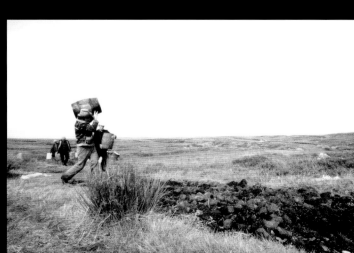

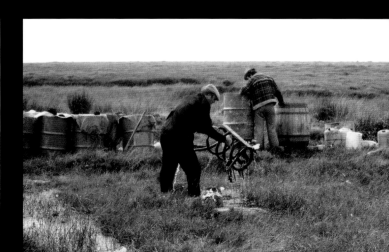

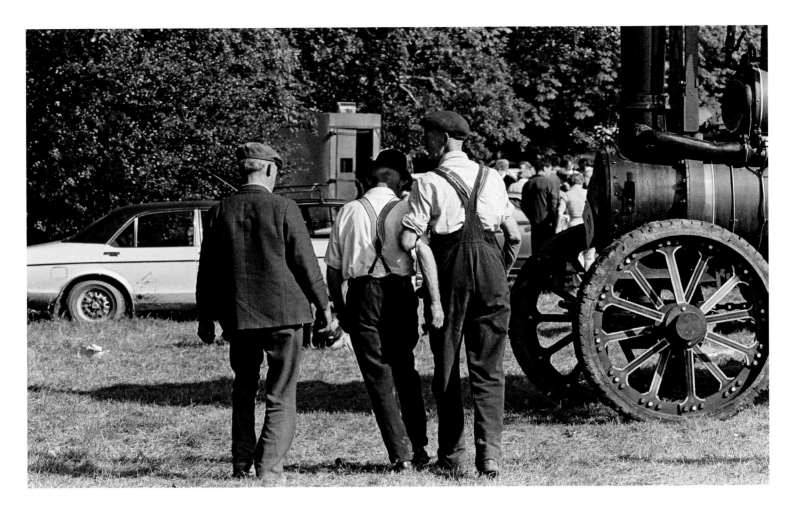

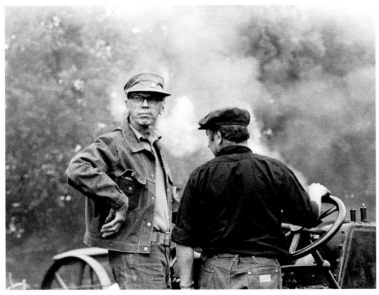

While holidaying with friends near Vicarstown, County Laois, in the early 1970s, I visited this steam rally at Stradbally. This was definitely an eye-opener for me – as a Dublin kid I had never seen anything like it. Vintage tractors, steam engines and machinery are all proudly displayed, opening up a whole new world of pictures. This event, on the same site as the Electric Picnic music festival, is still going strong, and I still love to cover it.

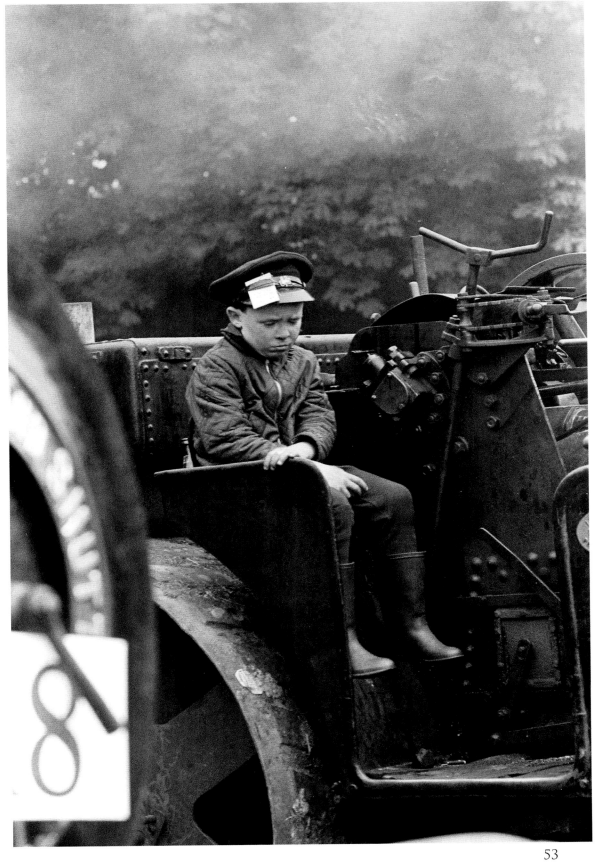

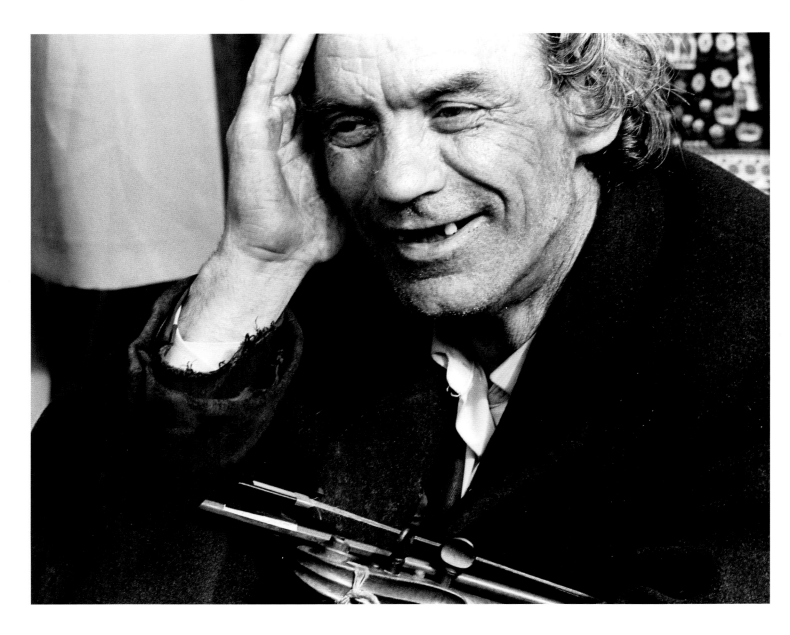

Above: A street fiddler, taking a break from busking, outside of the formal sessions at a fleadh cheoil in Ennis, County Clare, 1978. What a wonderful face.

Opposite: Sometime in 1978, I was heading back to Dublin from a weekend away. A friend told me to look out for a lovely traveller family, a mile outside Galway on the Dublin road, living under tarpaulins at the side of the road. I called in and asked if I could take some photos. This man provided a tinsmithing service – he could make a bucket, or fix a hole in one. It was a unique opportunity to catch a dying craft.

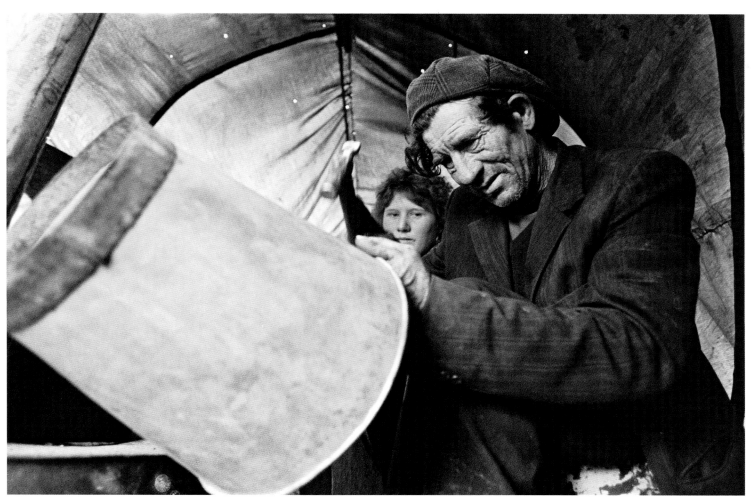

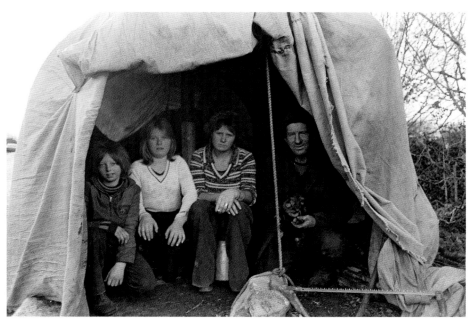

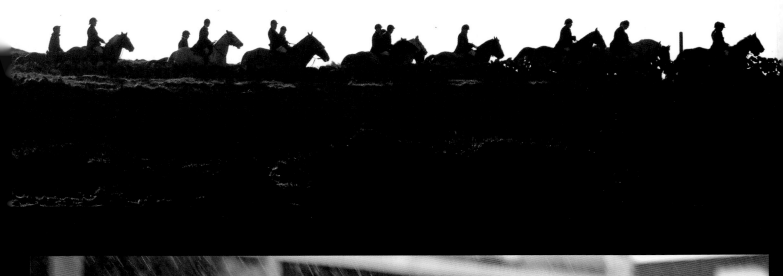

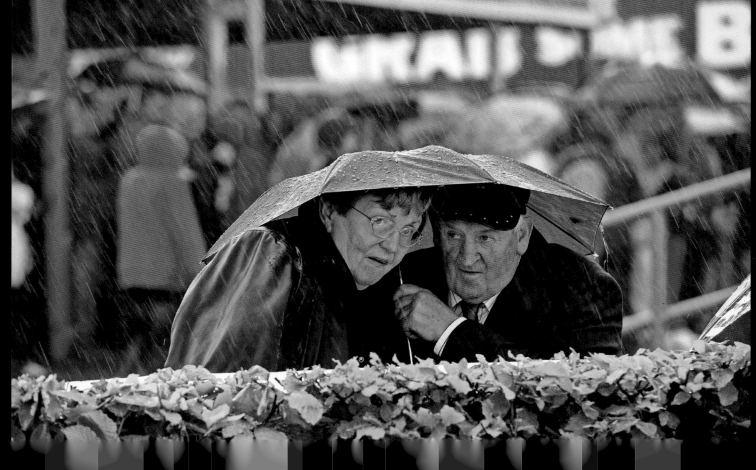

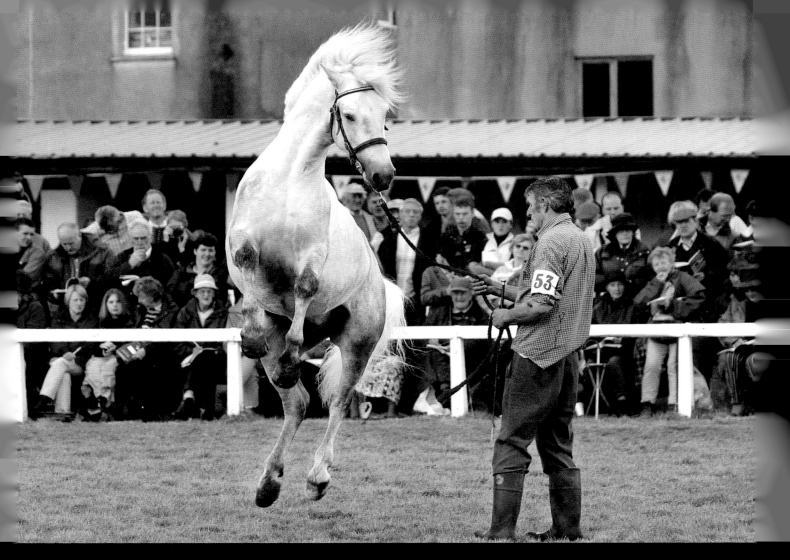

Above: The annual Connemara Pony show at Clifden, County Galway, 2001. John Reaney from

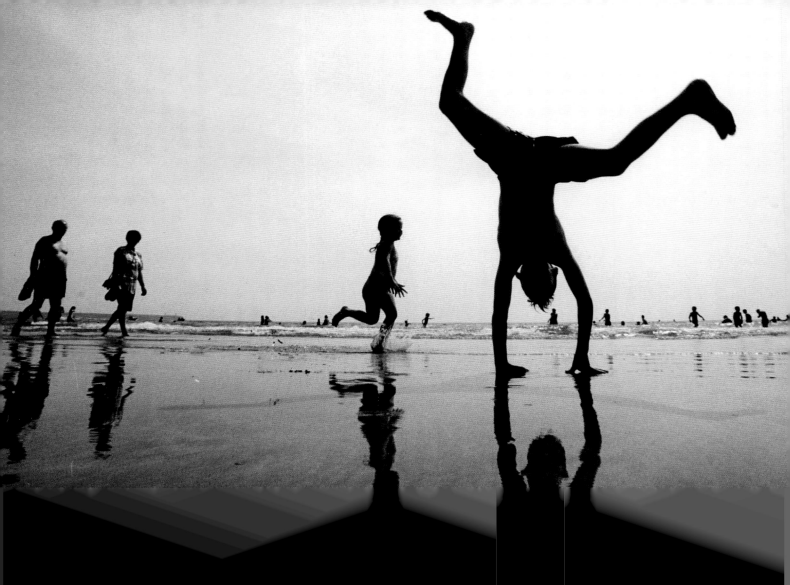

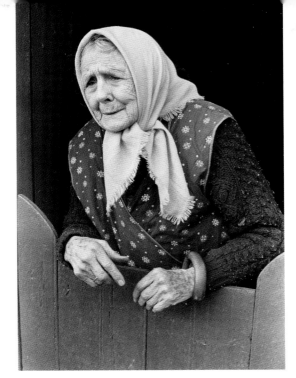

Two faces of the west of Ireland, 1980s.

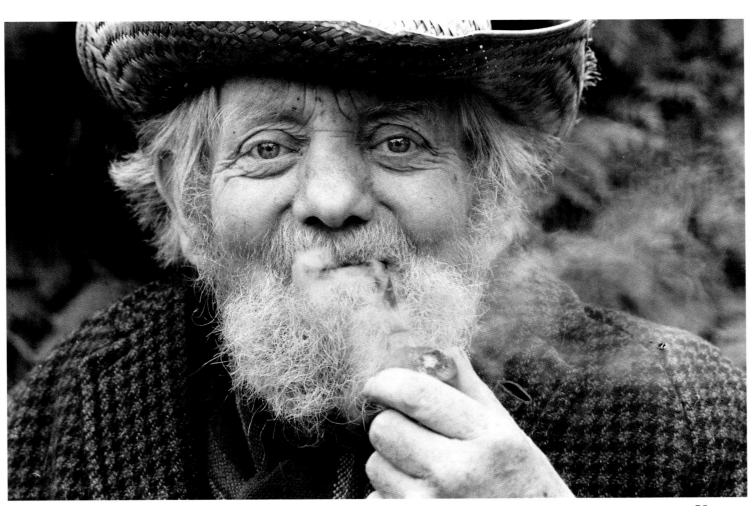

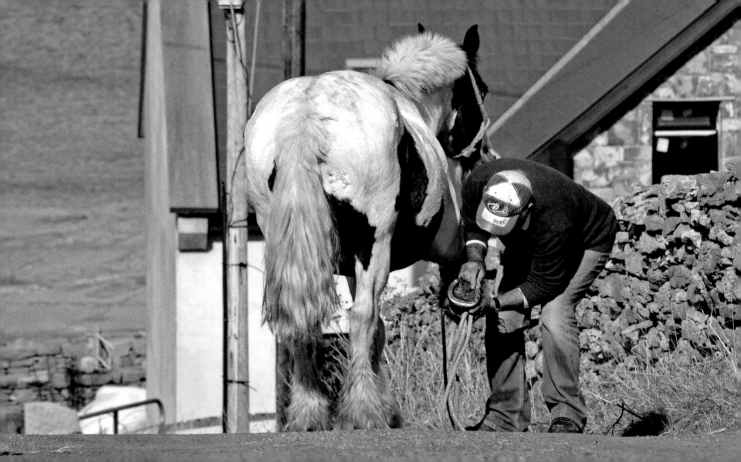

Between events at a greyhound meeting in County Meath, an owner takes time out to wash his greyhound in a pool of water in the middle of a field.

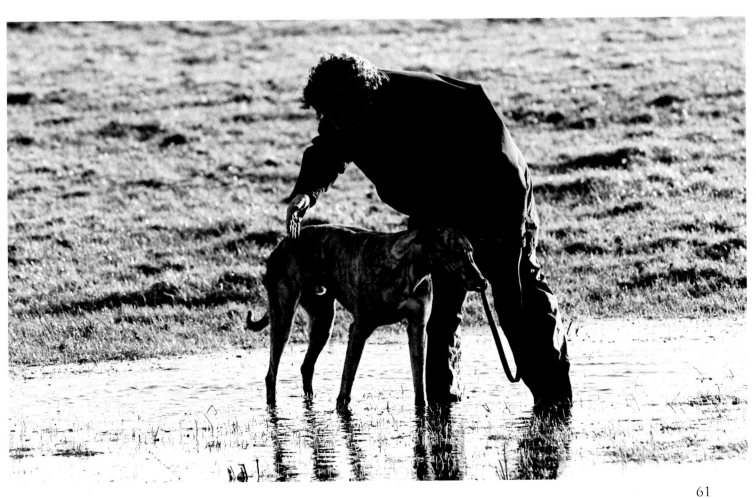

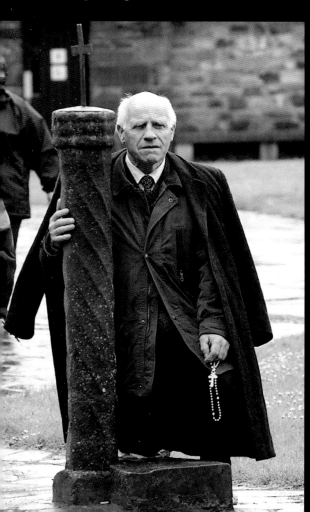

A pilgrim on the opening day of the 'three-day pilgrimage' season at Lough Derg, 2000.

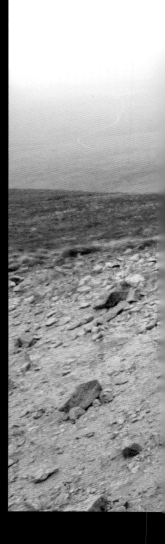

Pilgrims negotiate the difficult terrain during the annual pilgrimage up Croagh Patrick, County Mayo, 2006.

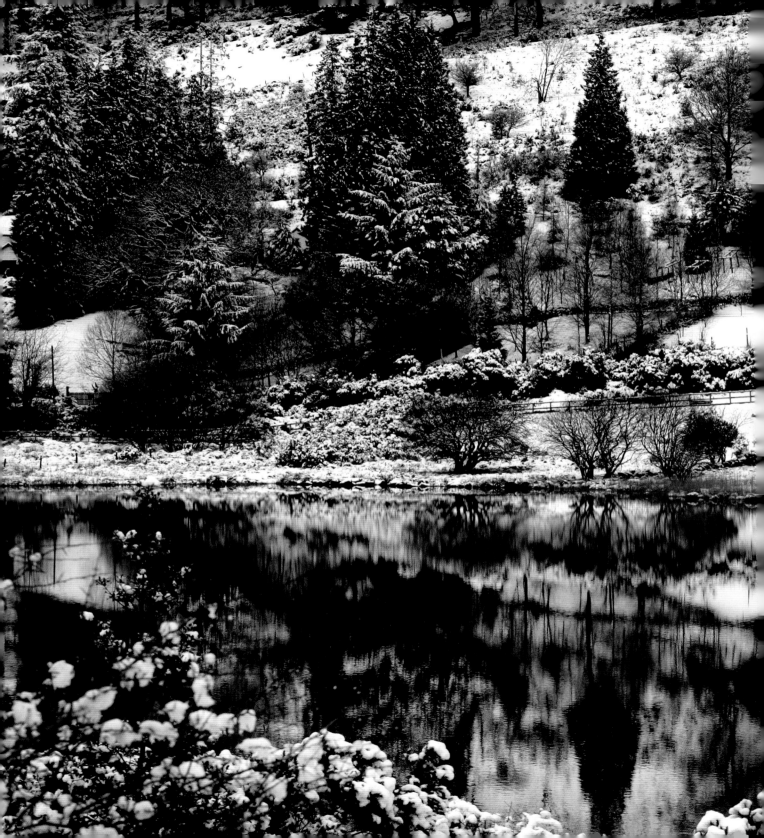

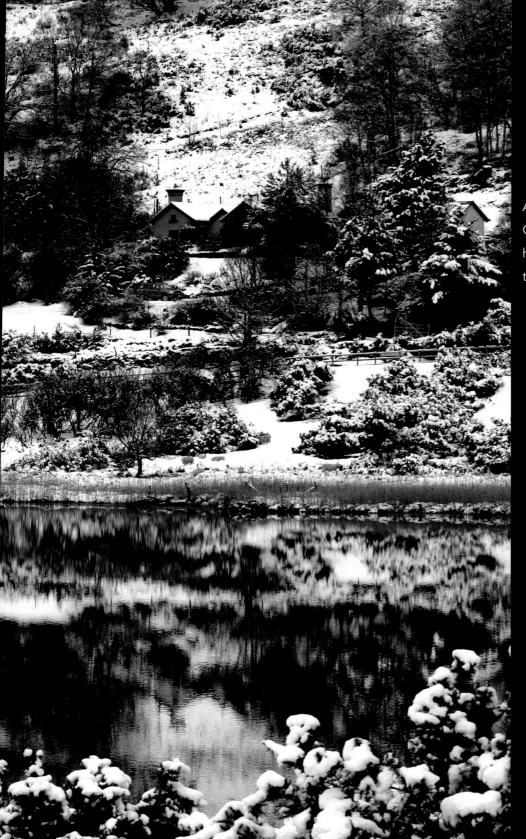

A wintry scene at Glendalough, County Wicklow, 2005. The snow has stolen all of the colour from the landscape.

PERSONALITIES

A lot of these well-known faces were people I came across in my leisure time, from photographing Martin Sheen surrounded by locals on the main street of Dalkey, to Gabriel Byrne in St Stephen's Green. Far from the red carpet, the best pictures can often be of a person in a more relaxed, casual environment. Without the red ropes and the trappings of formality, most people loosen up and a more genuine character comes through. I'm lucky to live in a quiet coastal village in south County Dublin, and occasionally bump into a celebrity or well-known personality when I'm out for a walk. On asking permission to shoot a picture, I find most people respond positively and graciously.

In my work, I often end up on a platform or a stage, shooting photographs of personalities at official engagements. These pictures provide a visual record of the event, but rarely a decent photograph.

On assignments I have covered seven presidents of Ireland: De Valera, Childers, O'Dálaigh, Hillery, Robinson, McAleese and Higgins, as well as numerous taoisigh and other political figures. In general I find the further one gets from the capital city, the more people loosen up, and the better the pictures that can be got.

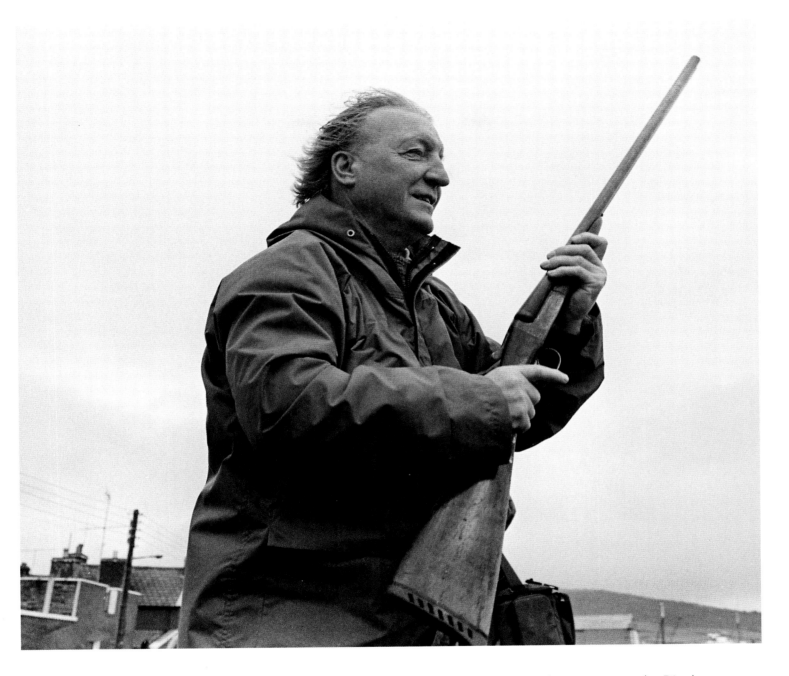

Former taoiseach Charles Haughey uses a shotgun to start the Dingle Regatta, in the late 1970s. Up until his death in 2005, Haughey's starting shot was part of the colour of the event. The tradition was continued by his eldest son Conor.

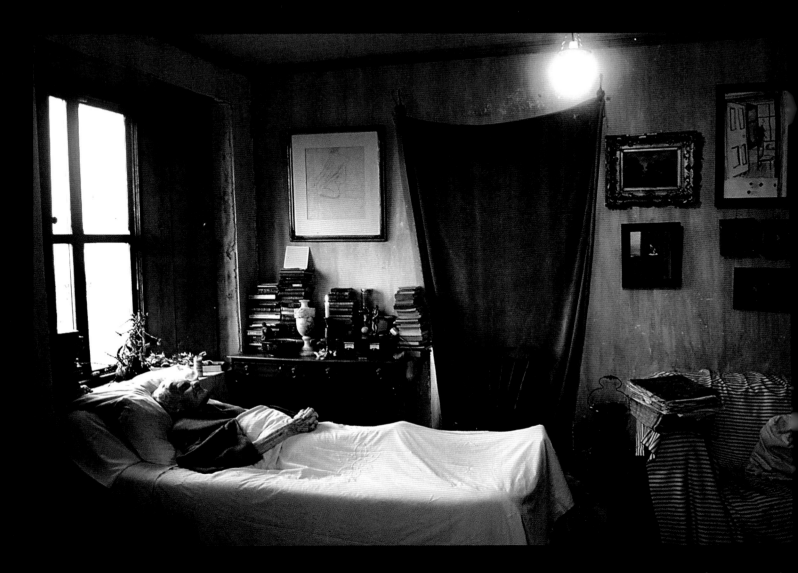

I was dispatched by the *Irish Times* to photograph artist Finola Graham at her home in County Clare in February 2000, as she had an exhibition due to be launched. On arrival, she told me that her husband, the writer Francis Stuart, had just died, at ninety-seven. I assisted in laying out the famous writer, and asked for permission to photograph him before the wake. With the dominant light coming from a naked bulb dangling from the ceiling, and a backdrop of his books and personal effects, a set designer in the Abbey theatre could not have produced a more dramatic backdrop for the artist's exit.

This was not the picture I had gone there to get, but I ended up recording a small piece of history in a small village. It was a far cry from the enormous funeral that followed.

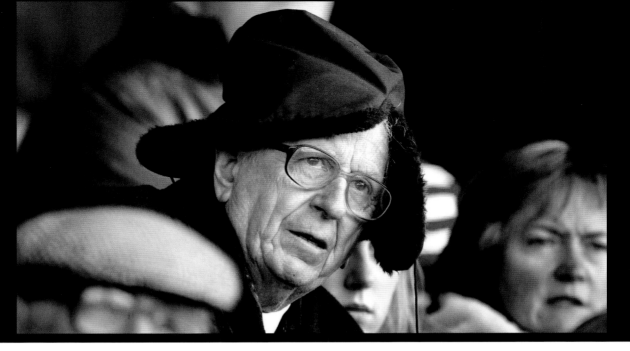

Above: A chance encounter at a schools' rugby match in Donnybrook produced an unusual photograph of the former Taoiseach, Dr Garret FitzGerald. Never one to court privilege, he was in amongst the parents, complete with practical headgear, cheering on his grandson. This is a far cry from the trappings of office, as he is seen here on an election tour **(below)** on a private jet with his wife Joan.

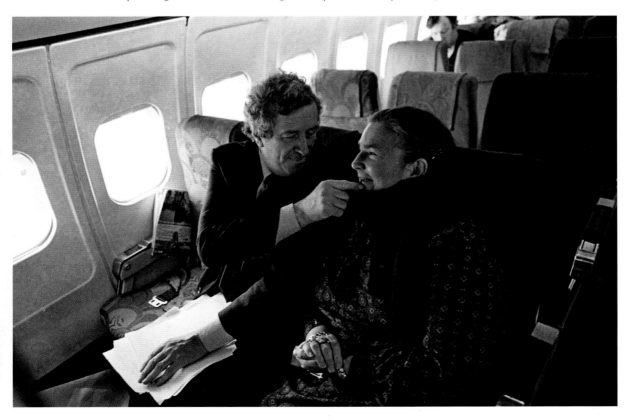

Cardinal Tomás Ó Fiaich, Roman Catholic Bishop of Armagh and Primate of All Ireland, and recently created Cardinal, with photographer Colman Doyle in Armagh, 1979.

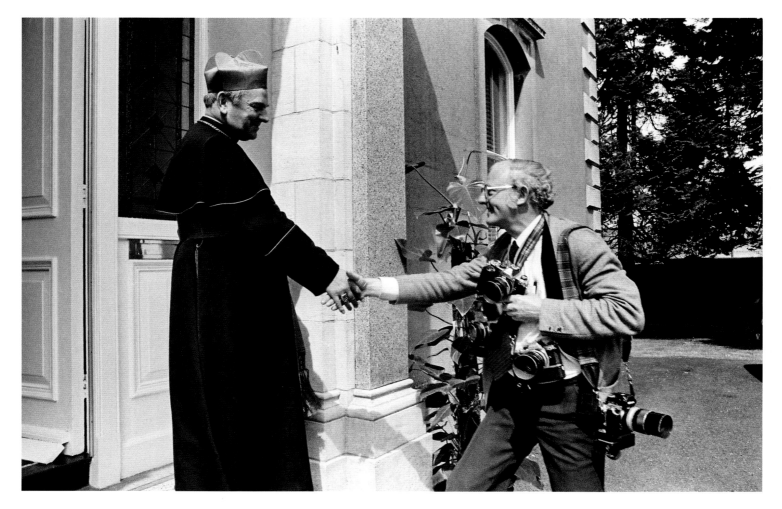

Opposite top: One of my earliest pictures for the Press group, and my first State occasion to photograph, was of the inauguration of President Patrick Hillery for his first term of office, in 1976. A team of photographers was dispatched to Dublin Castle and, as the most junior, I was given what was deemed to be the poorest position. Following the ceremonial swearing in, I would see the procession enter the courtyard, before disappearing from view seconds later. I spotted the President's daughter

Vivienne popping her head out, and set the manual camera focus on where her head might pop out again. Grabbing three frames, in the middle one I got lucky. This turned out to be the picture of the day, the front page of the *Evening Press*.

Opposite bottom: Roughly a quarter-century later, having just joined the *Irish Times*, again a president came to my aid, the inauguration of President Mary Robinson in 1990 providing my first colour front page.

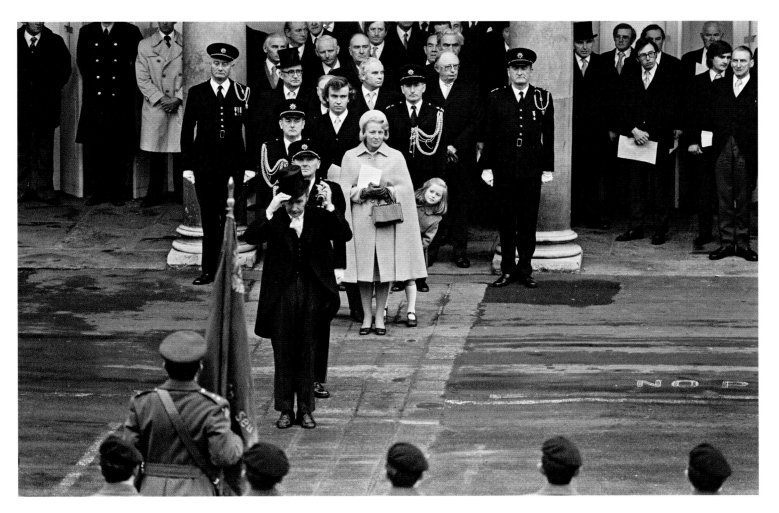

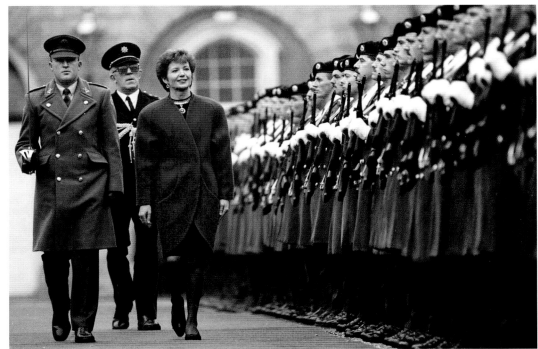

71

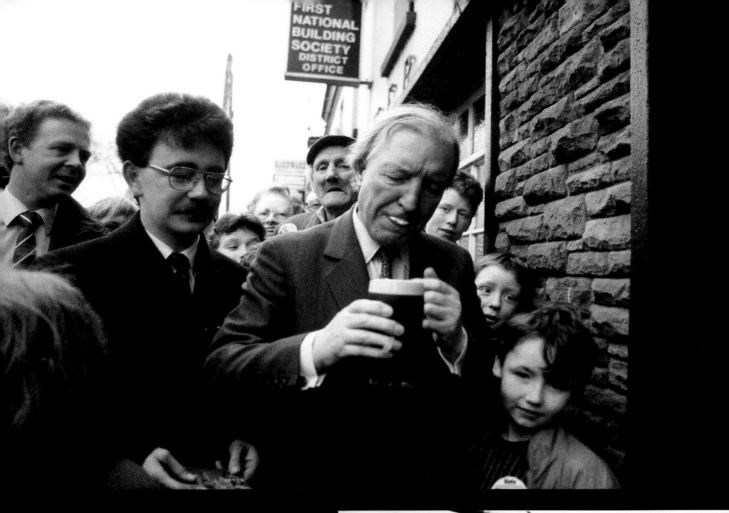

Charlie Haughey with a creamy pint of Guinness in hand stood in contrast to his usual abstemious lifestyle. He had been criticised by opposition figures for being a drinker, and so was strictly teetotal for a decade before this. You would be more likely to see him getting in and out of helicopters.

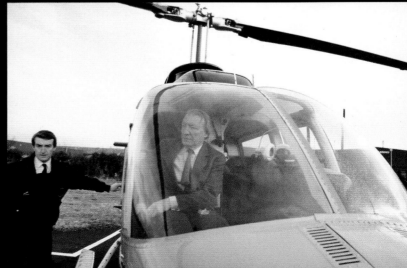

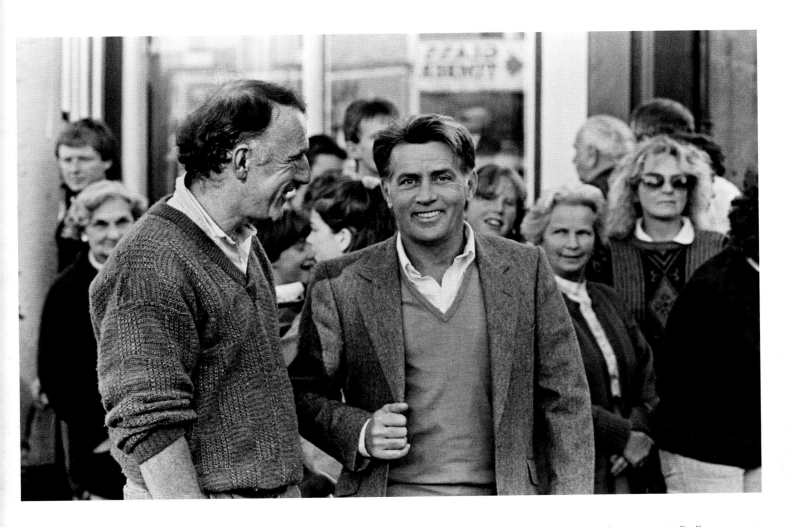

I happened to see Martin Sheen on the street in Dalkey, on the set of the Hugh Leonard movie *Da*. A local man, Des O'Brien, asked if I would shoot a picture of him with the actor, and I agreed only if he got permission from the movie star himself. Sheen very graciously beamed a smile into my lens.

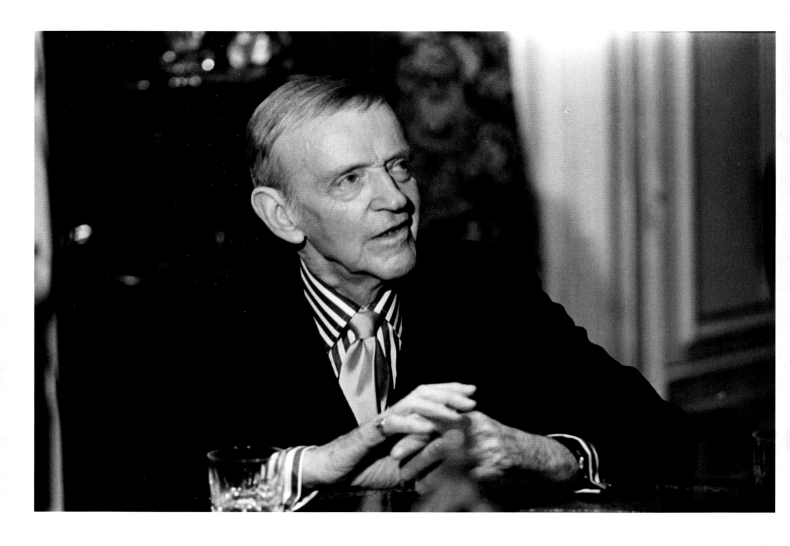

Above: Acting, dancing and singing legend Fred Astaire, on the set of *The Purple Taxi* in Ardmore Studios, Bray, County Wicklow, in 1976. The film was released the following year.

Opposite top: Queen Elizabeth II and President Mary McAleese at the Irish War Memorial Garden, Islandbridge, during the historic four-day State visit in May 2011.

Opposite bottom: A television monitor shows live pictures from the address by Sinn Féin President Gerry Adams, at the Sinn Féin Ard Fheis, in the RDS, Dublin, 2003.

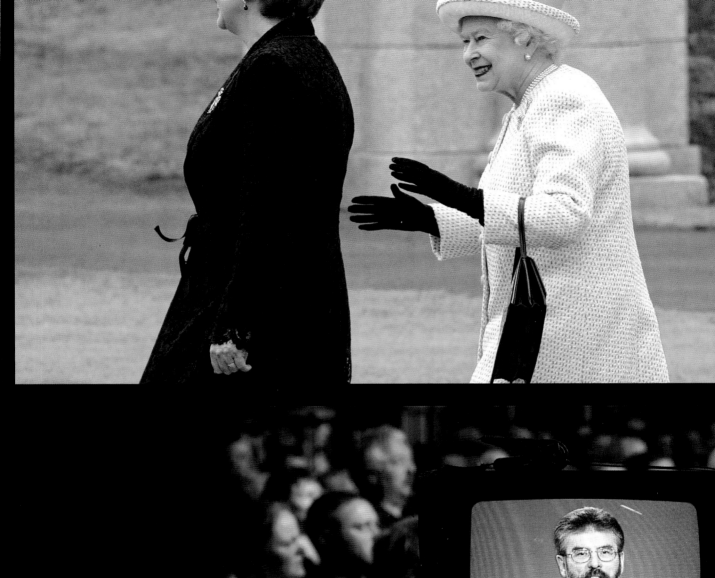
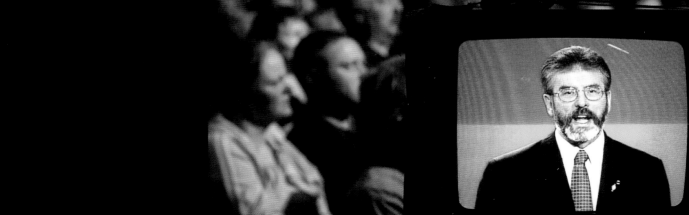

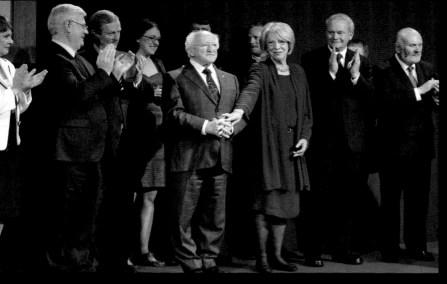

Above: Michael D Higgins is declared winner of the presidential election, 29 October 2011. **Right:** President Higgins at his inauguration as ninth president of Ireland, 11 November 2011.

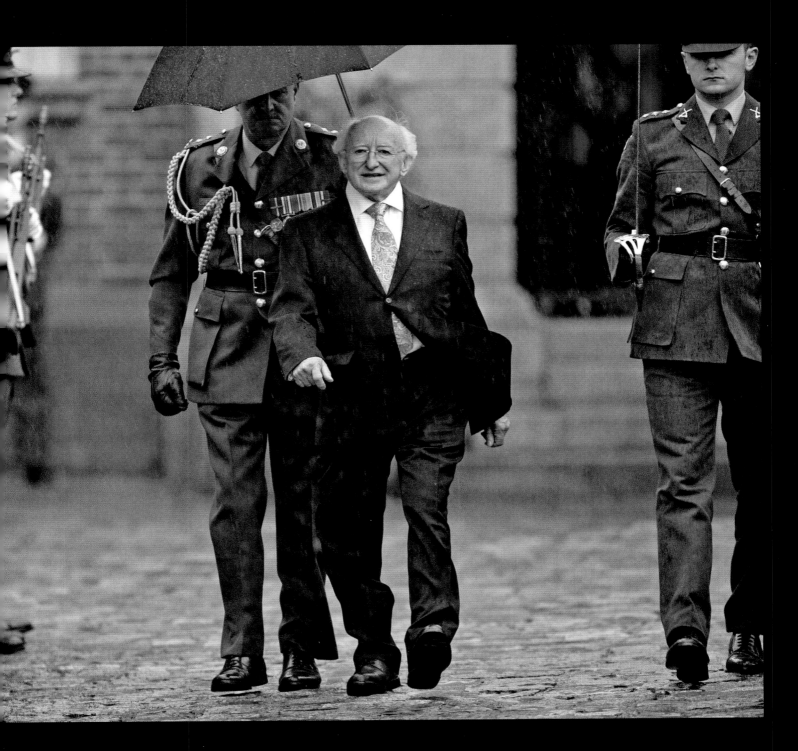

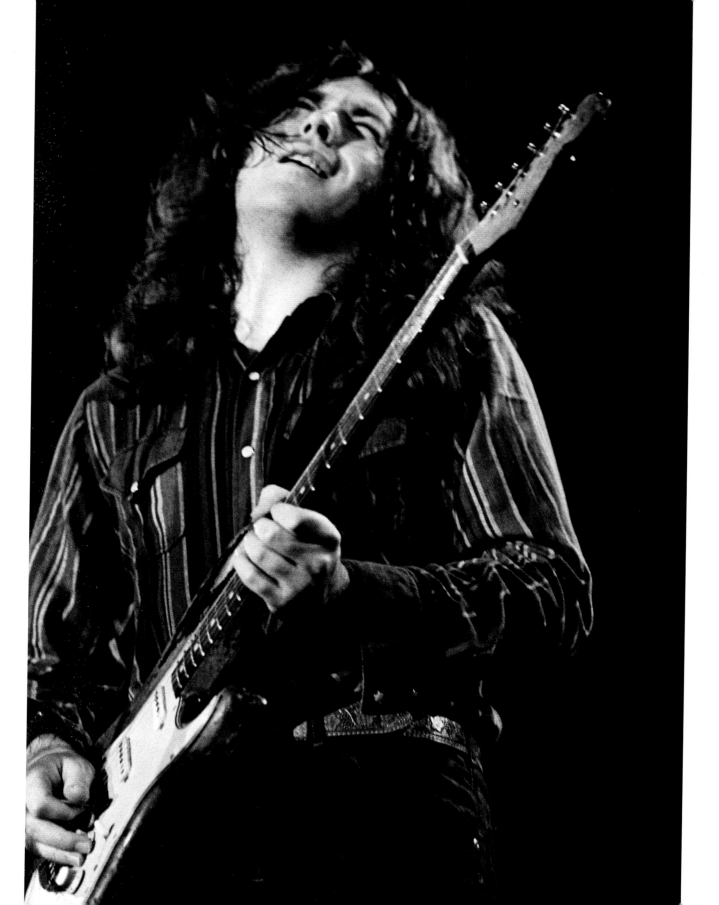

MUSIC

As a kid with a camera, it seemed the obvious thing to do – to photograph bands on stage, grasp the opportunity to mix being a fan and attempting to capture the essence of a live performance.

Dublin was hopping in the early 1970s. I could skip from venue to venue, photographing artists like Rory Gallagher, Phil Lynott, Bob Geldof, Christy Moore, The Dubliners and many more.

Nowadays, a photographer must apply in writing for permission to photograph a gig, signing away his or her rights to their own work, and is controlled in most aspects of the shoot. Four decades ago, I could arrive at the stage door, stroll in to the concert, and shoot away to my heart's content. Security personnel, or 'bouncers', were thin on the ground, and the freedom of movement was exhilarating.

I got to see and hear the powerhouse bassist and vocalist Phil Lynott, with Dublin's unparalleled hard rock group Thin Lizzy. Using every inch of the space on stage, dressed all in black, belting out the chords, Lizzy were a force to be reckoned with, and Phil Lynott, ever the showman, played constantly to the camera.

Working with film cameras, while a discipline in itself, means a smaller SLR camera body, and less obtrusive equipment overall. Current digital cameras come with large power packs, and photographers currently work with long lenses, so that flexibility and the ability to move around without drawing attention to oneself has diminished somewhat.

It is one of the great pleasures of working as a photographer – rare opportunities to get close and personal, much closer than the average punter, with legends of the world of music.

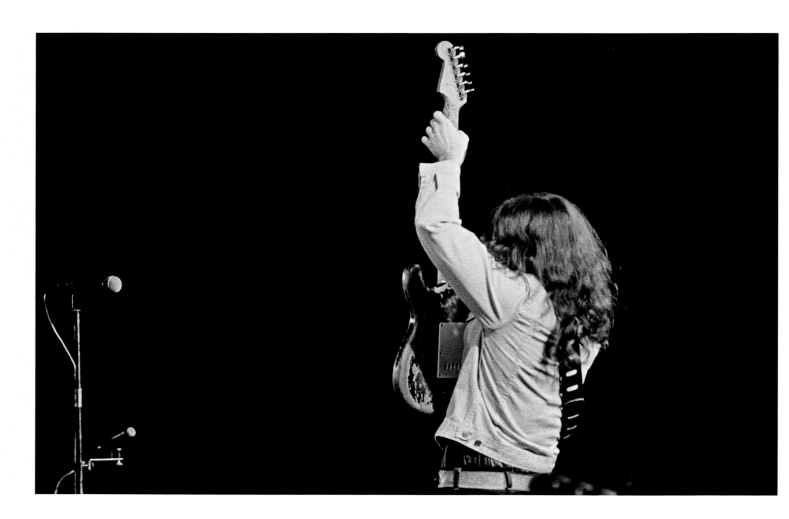

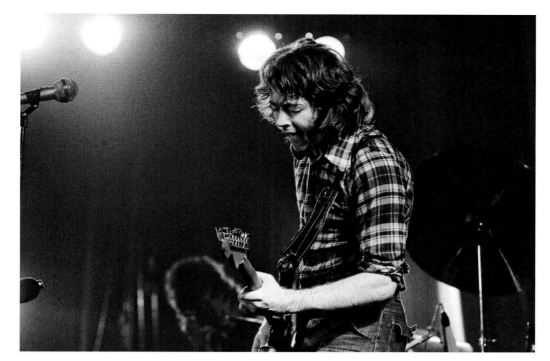

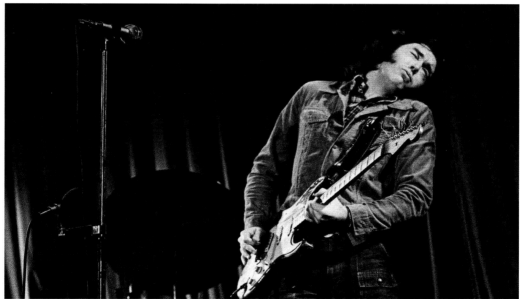

In the old Carlton cinema, opposite the Gresham Hotel in O'Connell Street, Dublin, the great blues guitarist Rory Gallagher took the stage in 1975. When Rory, on a tour of Ireland, appeared on stage, the hair (I had hair then) stood up on the back of my neck. I desperately attempted to follow him with my manual focus and manual exposure, as he charged around the stage. Raising his guitar towards the ceiling, lost in a sea of long hair, his profile is iconic and unmistakable. The Carlton has greatly fallen from grace, now housing a bag shop on its ground floor.

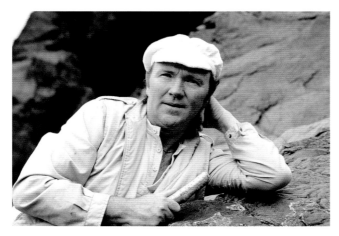

Left: I was fortunate enough to spend a weekend as a guest at Liam Clancy's home in Ring, County Waterford. I felt I was in the presence of a great artist. Early one morning, he posed for me on some rocky cliffs near Ardmore. **Below:** This low-light photo was taken in a cave, a far cry from the stage. Clancy had a very powerful physical presence, and even at these low light levels, you can detect a spark in his eye.

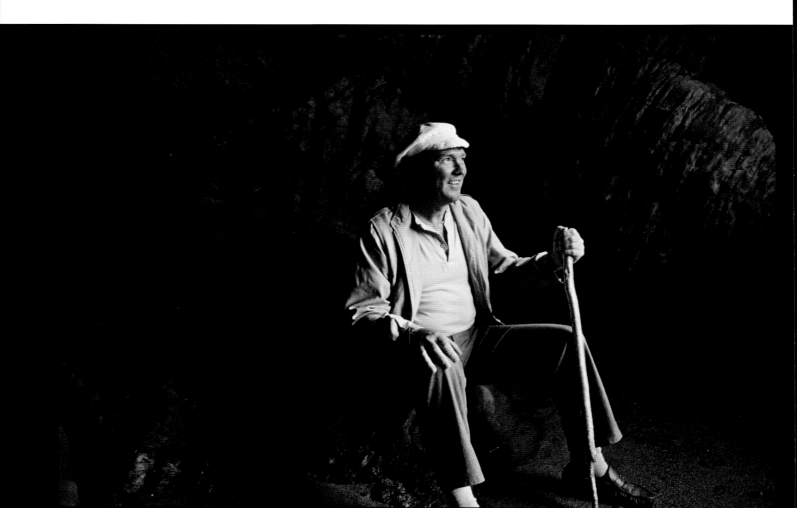

One of the best concerts I ever experienced was U2 at Croke Park, 1987. The rawness of those concerts contrasts strongly with the high-tech shows of today, thirty years later, with the performance being projected on a giant screen above the audience's heads. They wouldn't be allowed to chuck buckets of water over the audience these days. The only water now to be seen is a bottle of mineral water in Bono's hand. **Below:** U2 perform in the 'iNNOCENCE + eXPERIENCE' show, at the 3Arena, Dublin, 2015.

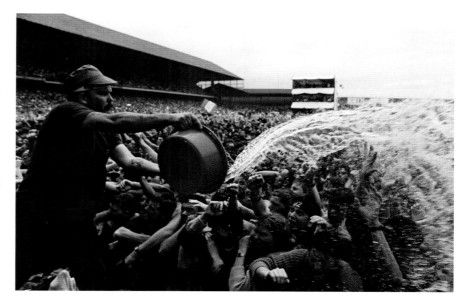

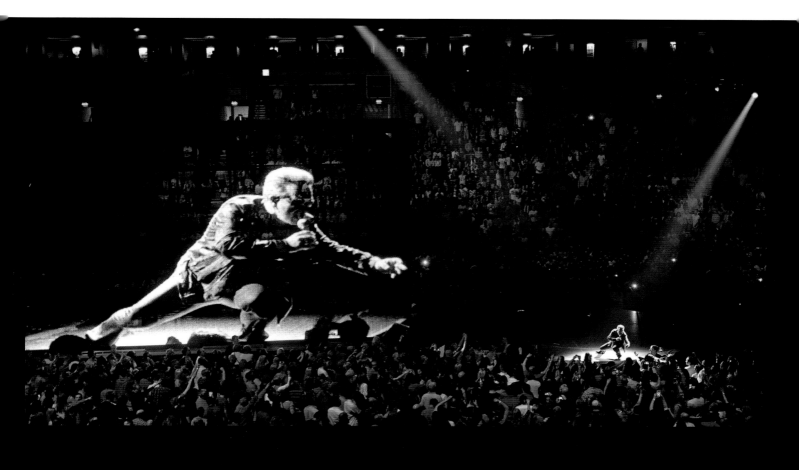

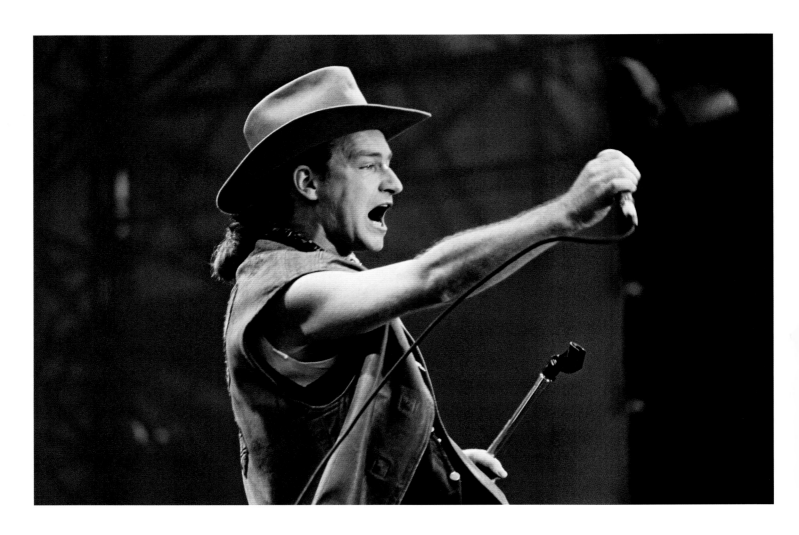

U2 at Croke Park, 1987.

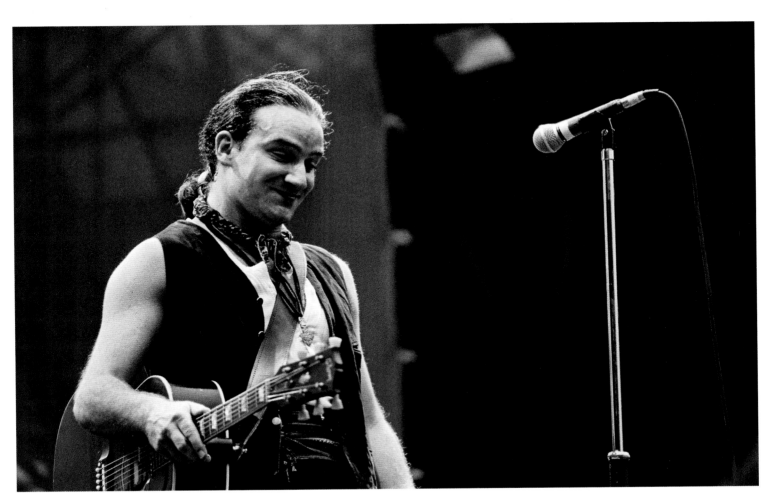

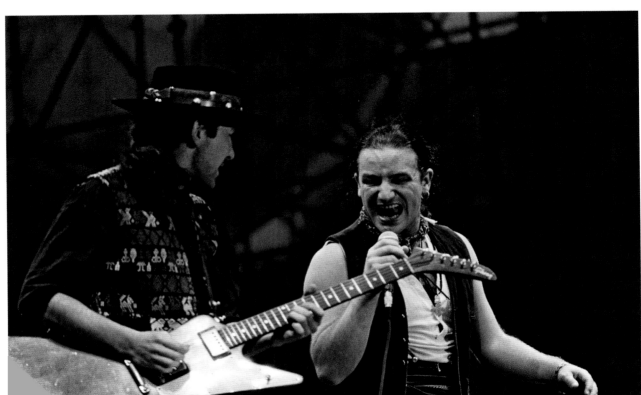

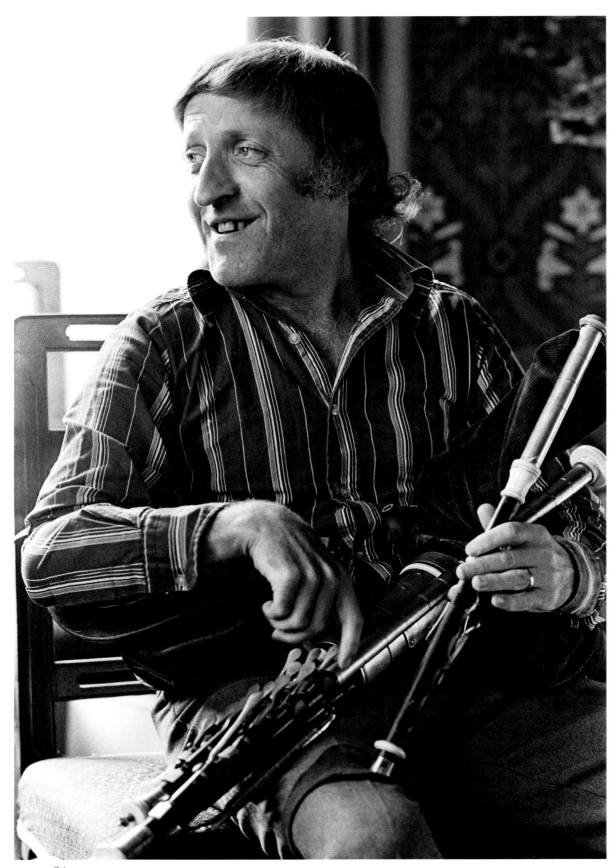

Opposite: Paddy Moloney keeping everyone feeling festive at a party at Lugalla, County Wicklow, the home of Garech De Brun, founder of Claddagh Records. I went down with John Boorman, after he made the movie *Excalibur*. Moloney played and played, and the guests danced the evening away.

Below and right: Gilbert O'Sullivan drives the audience wild at the Carlton cinema, O'Connell Street, 1974. O'Sullivan, originally from Waterford, was number one in the British top twenty. I was working in the Irish Press darkroom at this time. The audience is wearing rosettes, somewhat reminiscent of a horse show.

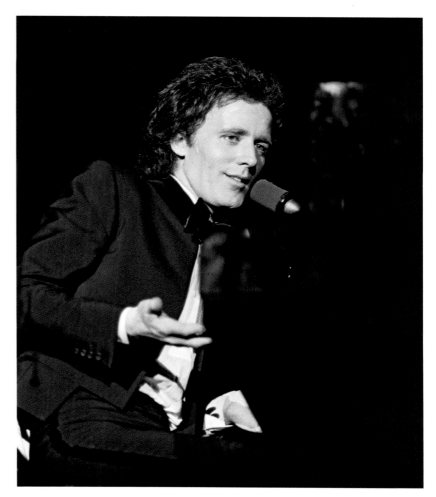

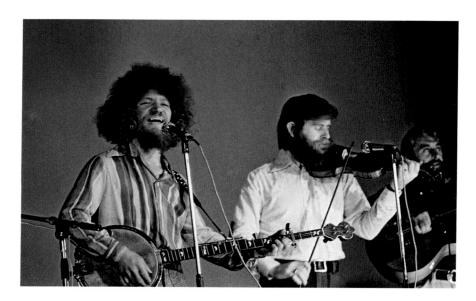

The Dubliners, 1970s: Four beards, and powerful stage presence. These were among the first photos I ever took, after working my way to the front of the crowd to capture the moment with a very poor, borrowed 35mm camera. Most of my shots were out of focus, though a few saved me. With subjects such as these, how could one fail? This was the only time I photographed The Dubliners onstage.

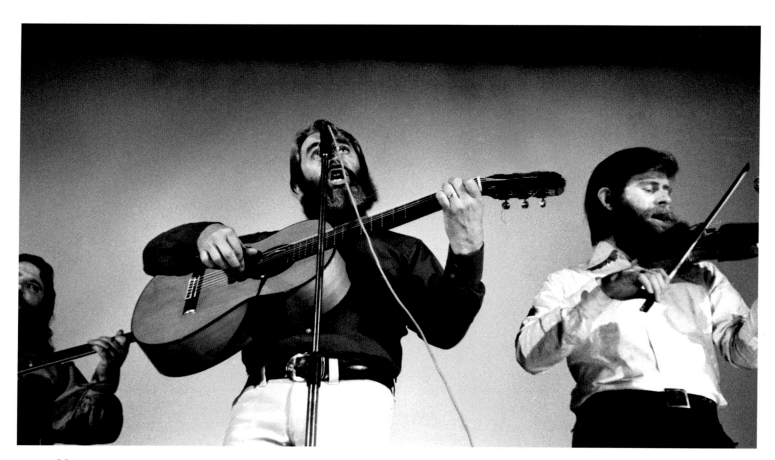

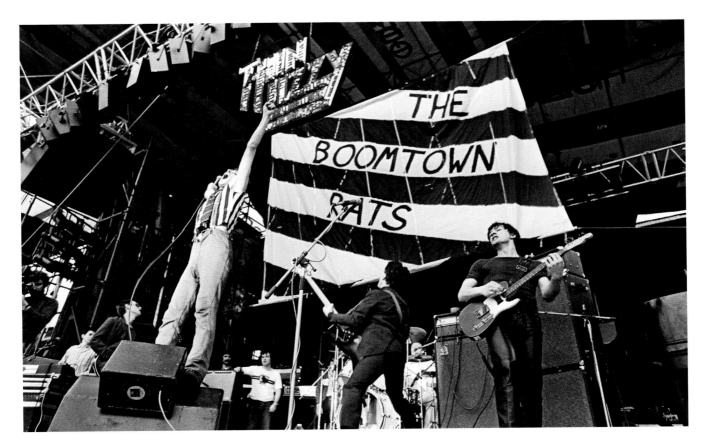

Above and bottom: The Boomtown Rats, with their charismatic frontman Bob Geldof, onstage in 1977.

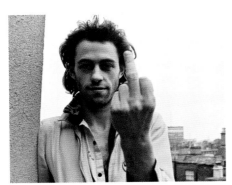

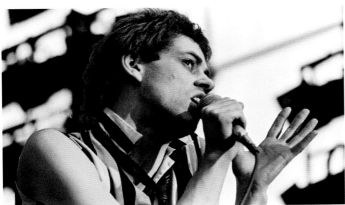

I was having a pint in Mulligan's of Poolbeg Street, in 1980. The reporter Tom McPhail approached me – could I take a picture of Bob Geldof? A friend of his, Fachtna O'Kelly, managed the Boomtown Rats. Geldof wanted his photo taken to make a point about Dublin being behind the times in terms of concert promotion – sound levels were being suppressed at an upcoming Rats gig, due to residents' objections. The concert was cancelled due to the dispute, but eventually went ahead at Leixlip Castle. Bob is still bouncing around the stage, and still speaking his mind, at seventy. **Left:** This picture was taken on the balcony of his penthouse at Bloom's Hotel, in what is now Temple Bar.

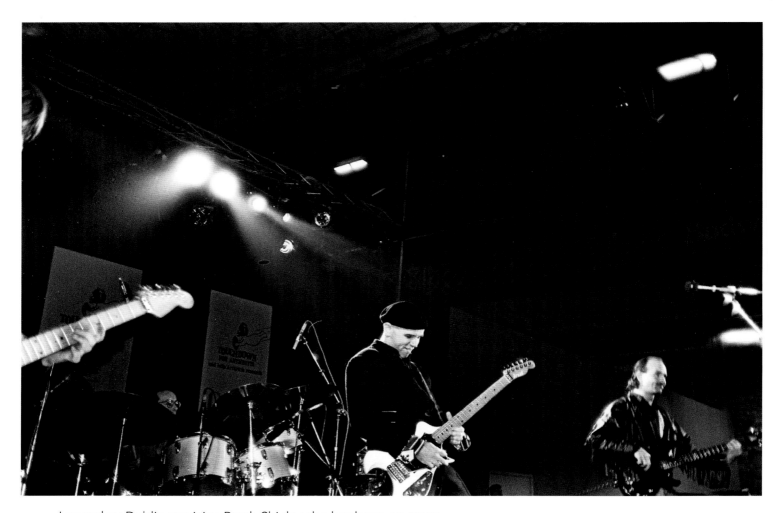

Legendary Dublin musician Brush Shiels, who has been on stage
since the 1960s. Shiels is credited with mentoring Phil Lynott, and
fronted Gary Moore's first band, Skid Row.

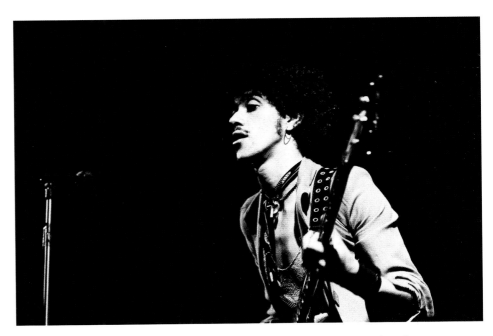

The unmistakable and incomparable Phil Lynott and Thin Lizzy, arguably Ireland's first real rock stars, take possession of the stage, 1977.

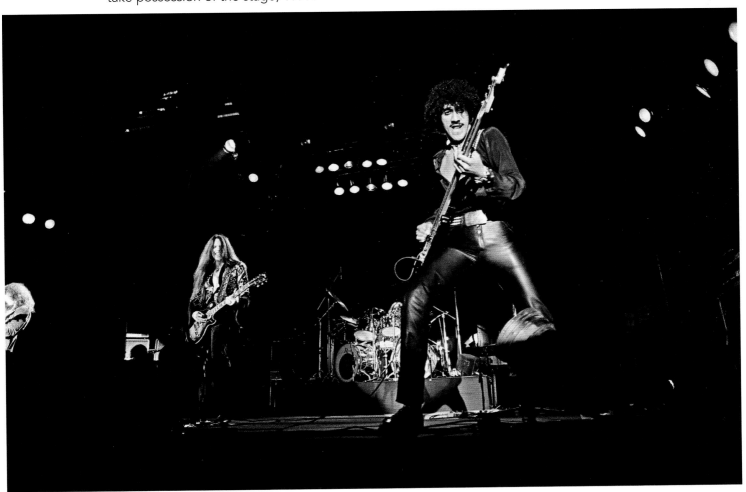

Below: Micho Russell at the first big weekend festival at Lisdoonvarna, the Electric Picnic of its time, in 1978. Micho, from Doolin, County Clare, was one of the Russell Brothers, along with Packie and Gussie, the only surviving member when I took this picture. These were probably the musicians who originally drew people to the now-famous traditional music scene in Doolin. The festival took place in a massive field between Doolin and Lisdoonvarna. The bill included the Chieftains, Christy Moore, De Danann, Stockton's Wing and Paul Brady. Russell played on his own on the huge festival stage, and had the whole crowd on their feet cheering.

Opposite: Christie Moore, possibly playing with Planxty, in 1974. It's nice to see him with a full head of hair.

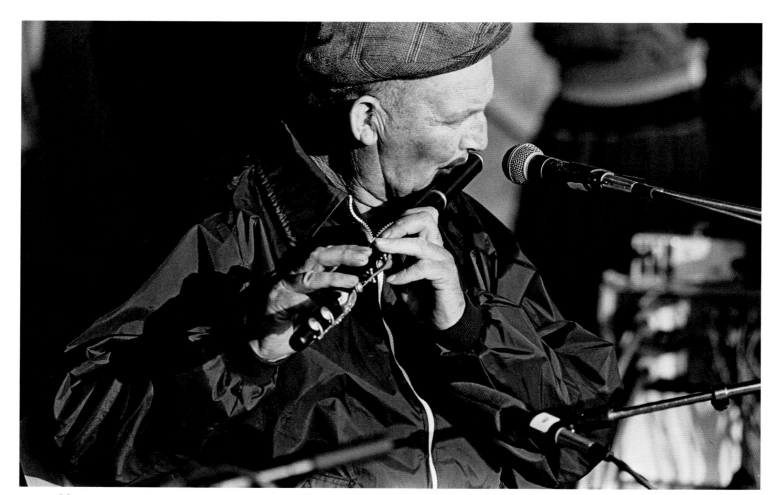

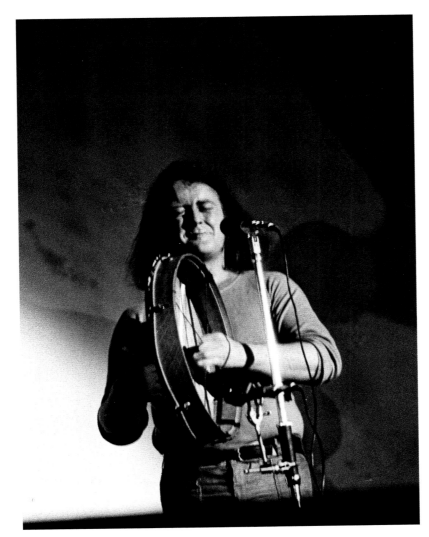

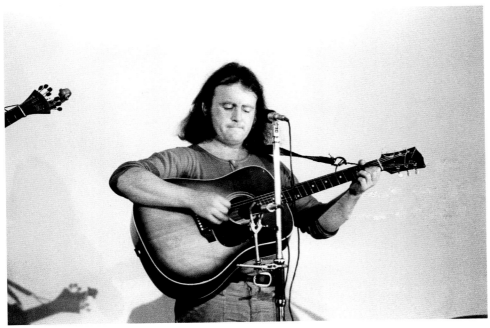

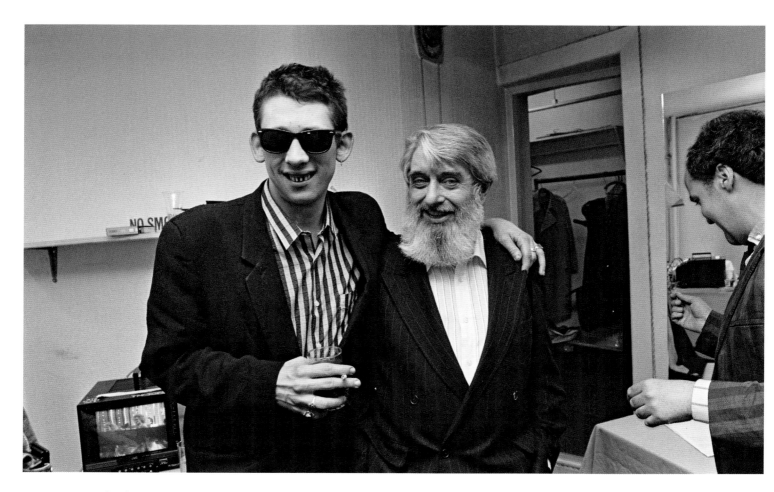

I was asked to come into the green room, backstage at the Gaiety theatre, and take a photo of Shane McGowan and Ronnie Drew. They were in great form, and Shane immediately threw his arm around Ronnie. Two great names in Irish music, and lovely to have a picture of them offstage.

The picture of Queen could have been taken in Birmingham, Alabama, but the bouncers are definitely an Irish phenomenon. Following an altercation at the foot of the stage, I went over to see what was happening. Being met by a large group of 'security personnel', I grabbed a few pictures and beat a hasty retreat. Truncheons would not be standard issue for today's security staff at a concert, as they are now much more tightly controlled and regulated.

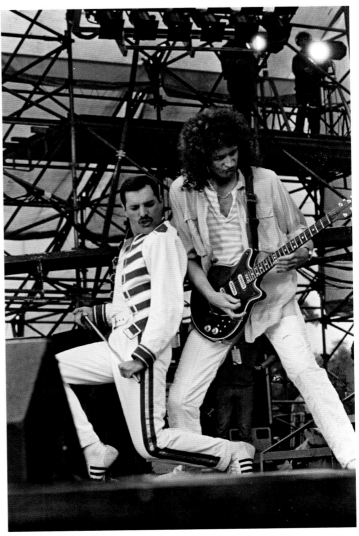

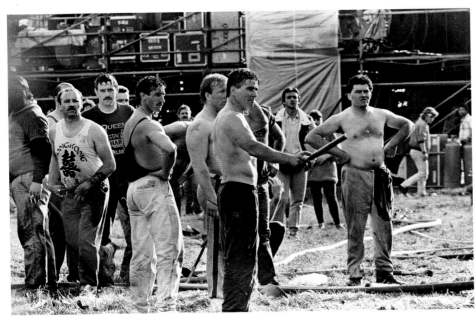

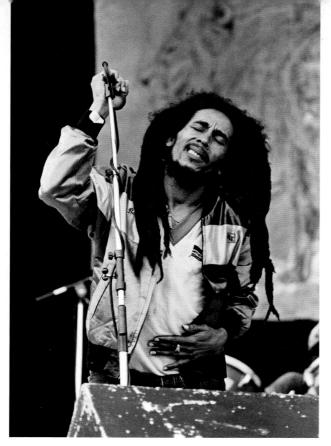

Another iconic head of hair: Bob Marley and the Wailers played at Dalymount Park in Phibsboro, on the northside of Dublin, on 6 July 1980.

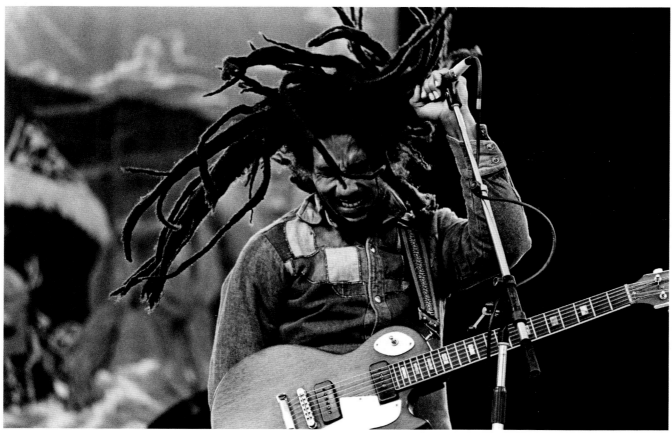

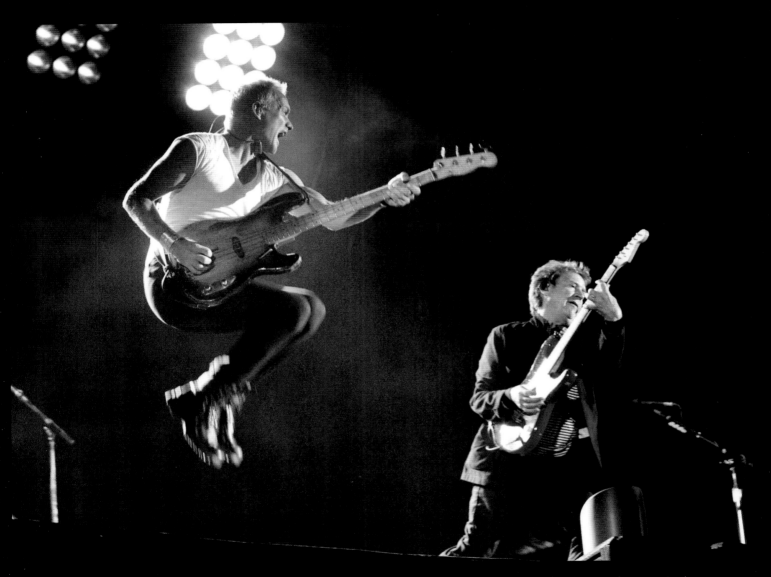

Sting and Andy Summers of The Police perform at Croke Park on a mild October's evening in 2007, as part of their reunion tour. Their only other Irish gig was at Leixlip Castle in 1980.

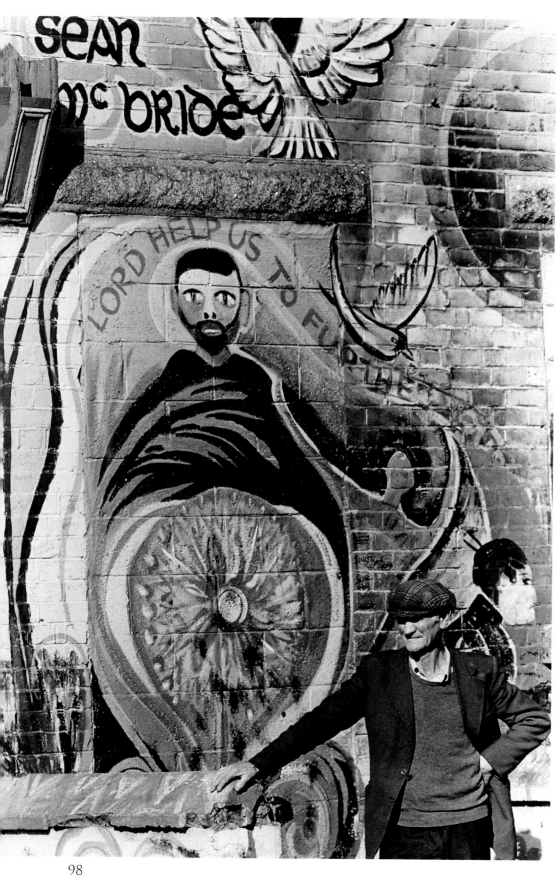

A mural to Seán McBride, a former Chief of Staff of the IRA and veteran of the War of Independence and Civil War. Later a government minister, he controversially ordered Noel Browne to resign over the Mother and Child Scheme.

SMITHFIELD

Until 2013, a horse fair was held once a month in Smithfield, in north Dublin. It has become a real feeding ground for photographers, but in the early days you could wander at will without seeing another camera. This is known nowadays as 'street photography'. The trick is not to be seen.

These characters and faces could have come from any part of rural Ireland, yet this is a stone's throw from O'Connell Bridge. You would see kids galloping up and down the wide-open cobblestoned square, the perfect platform for buyers and sellers to show off their wares, and the perfect opportunity for a lurking photographer.

Looking back at these pictures, things in the background, like the sign for Smithfield Cars, nowadays seem so evocative. The funny thing is, when taking the picture, you would try to cut that out of the background, and just catch the horses and people. In some cases the backgrounds in the photographs produce a fantastic context for the images. Most of this background is long gone now, as the square has been redeveloped, with the LUAS tram running through.

The fair is still held twice a year, on the first Sundays in March and September, now under stringent new regulations.

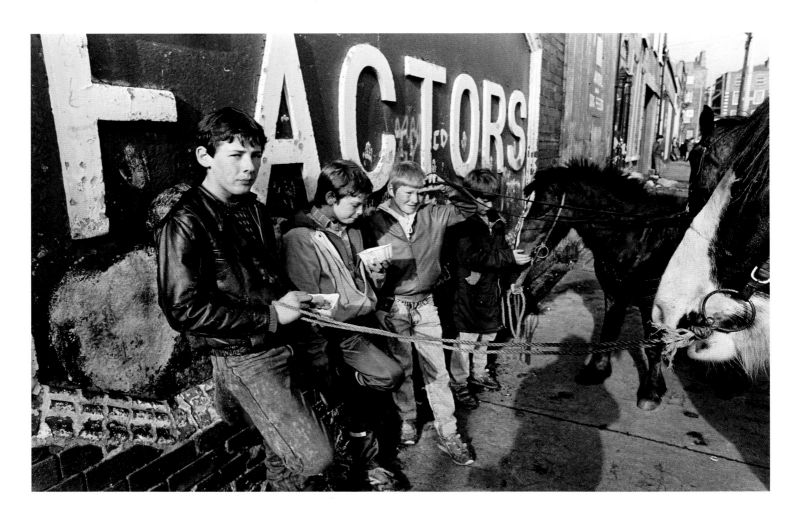

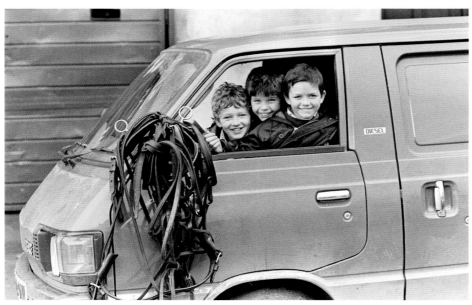

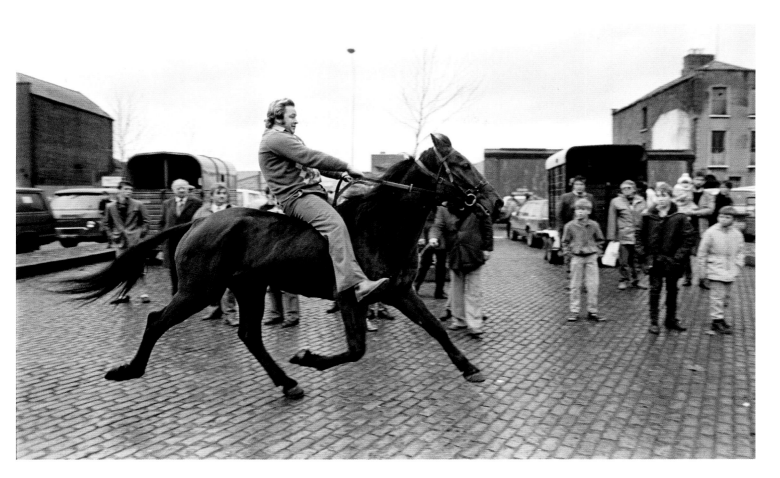

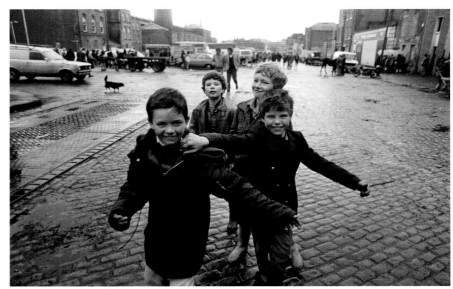

101

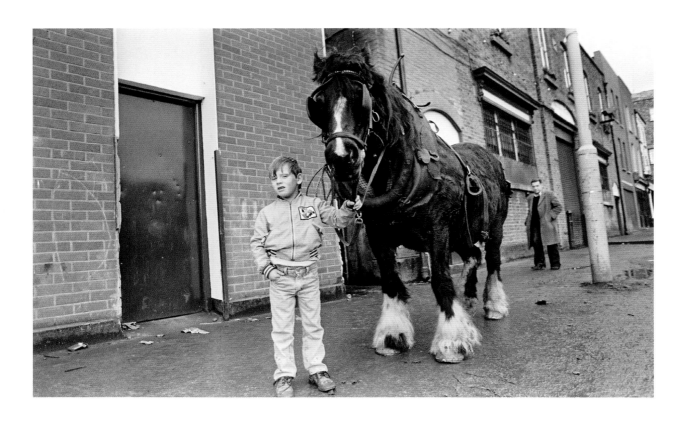

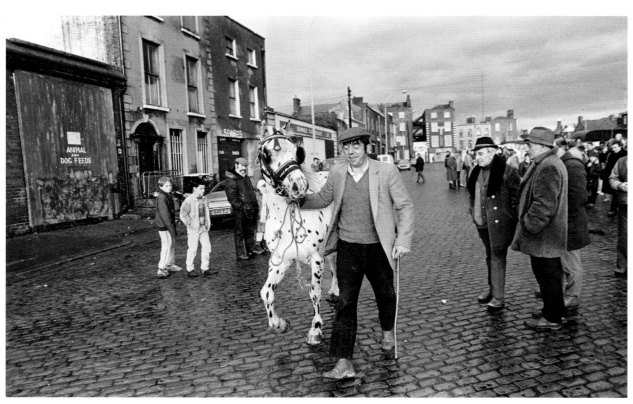

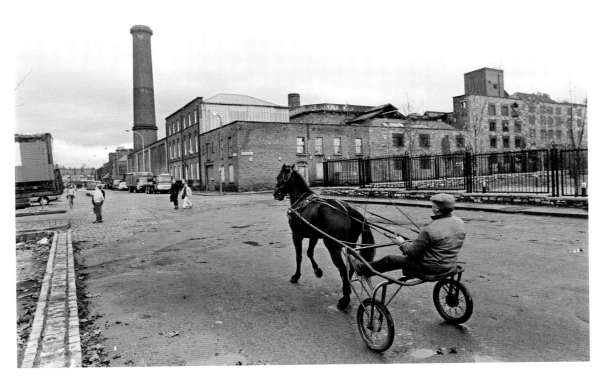

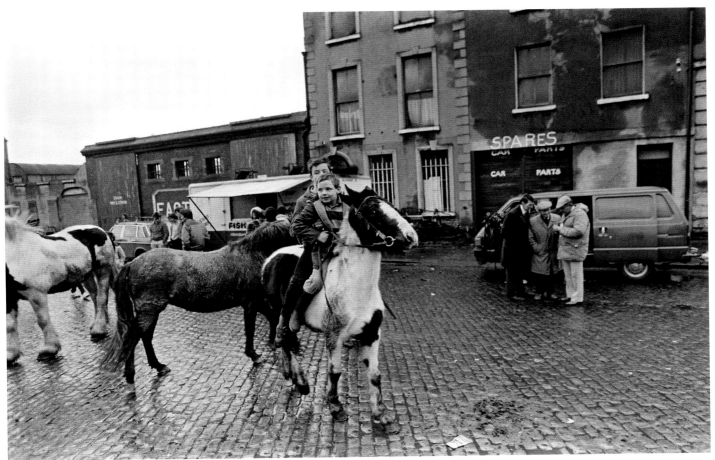

103

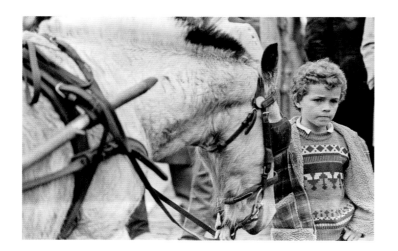

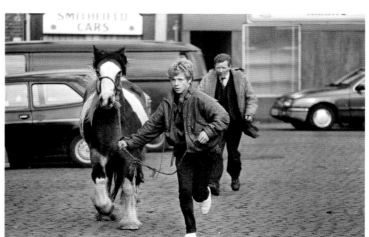

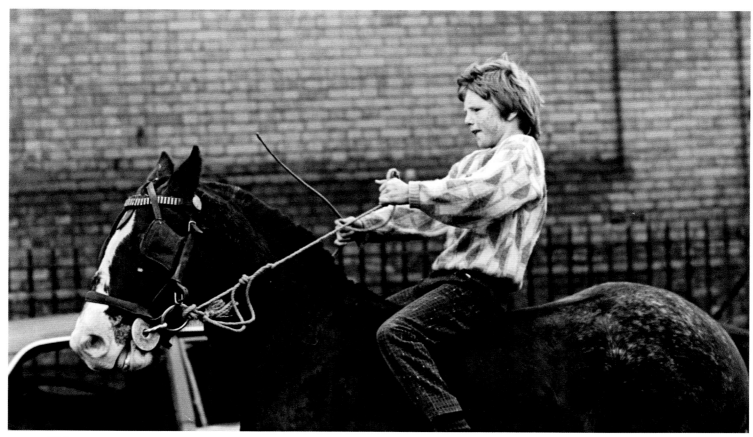

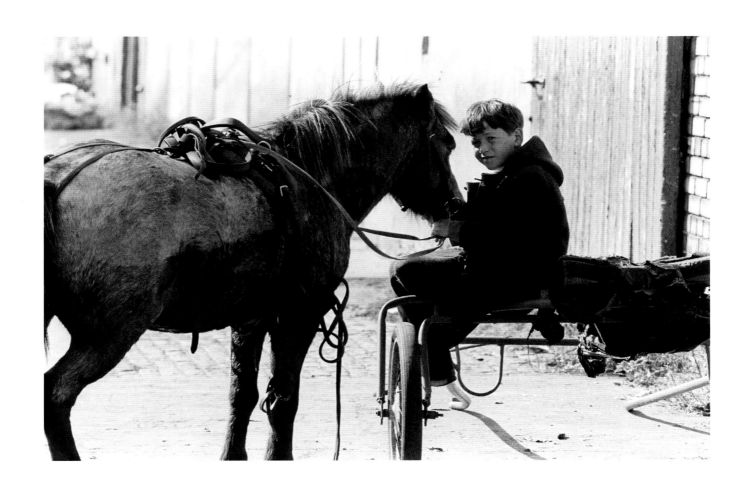

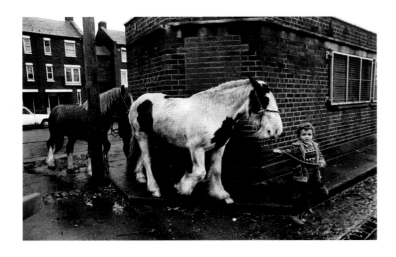
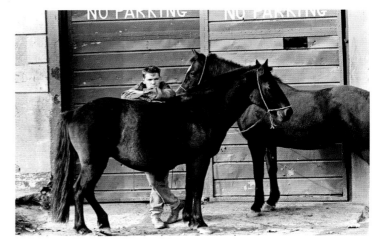

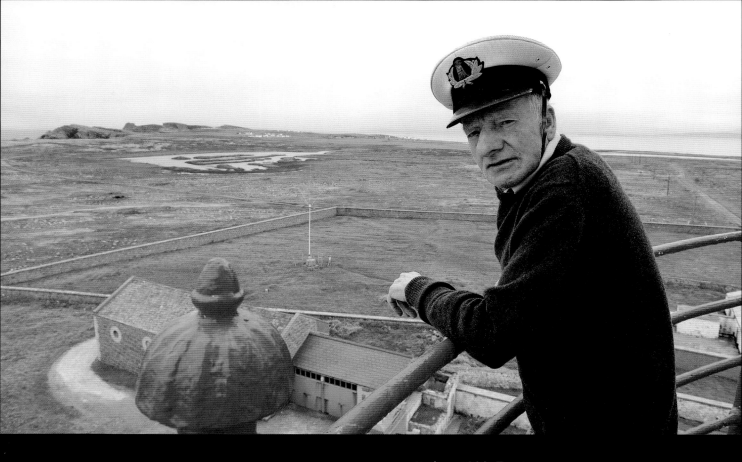

Built in 1832, Tory's twenty-seven-metre lighthouse was converted to automatic operation in March 1990. Sean Doherty was the last lighthouse keeper to work there. Irish Lights now run the lighthouse, while Sean runs the

TORY ISLAND

A bunch of children running along a road may not sound like the ingredients for a good picture. But when that road runs through the bumpy, twisting terrain of Tory island, almost ten miles off the northwest coast of Ireland, it cannot fail but to provide a perfect photo opportunity. I fell for the rugged beauty of Tory on my first visit, almost forty years ago, and have been returning on and off since then.

The original trip, in 1977, was a baptism of fire in some respects. The only means of getting to the island that day was by hitching a ride on a small fishing boat carrying a load of turf. I had to roll up my sleeves and help to load canvas Odlum's oats bags full of dry sods on to the slippery deck. This in itself provided an opportunity to capture a timeless tradition, as islanders converged on the pier on our arrival to unload the cargo, storing the valuable fuel for the upcoming winter.

With nowhere to stay and knowing no one, I felt a long way from home. However, it was not long before I was accommodated in a local cottage, with a warm welcome and memorable home-cooked food. That first visit laid the foundations for a photo essay with numerous participants, including the King of Tory himself. Patsy Dan Rodgers greets all visitors on arrival, and has been a landmark of the island since I started going there in the 1970s.

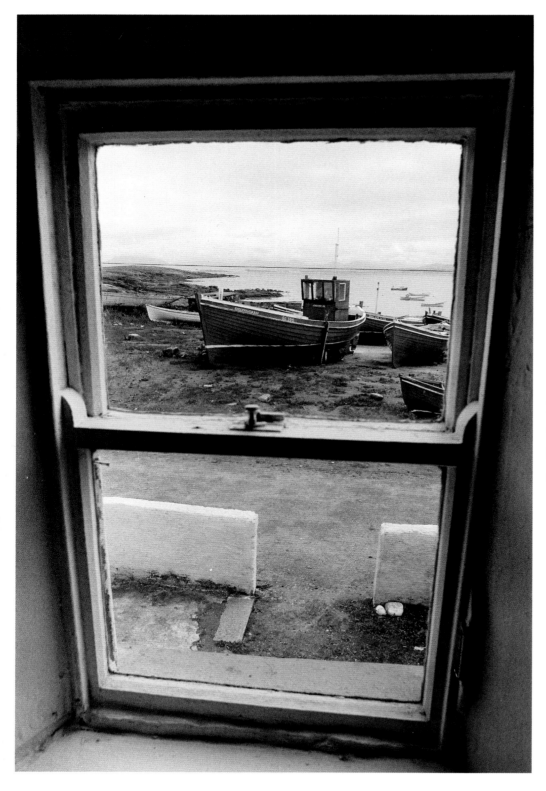

Left: A boat framed by a window on the island.
Opposite: Hauling a boat onto the beach.

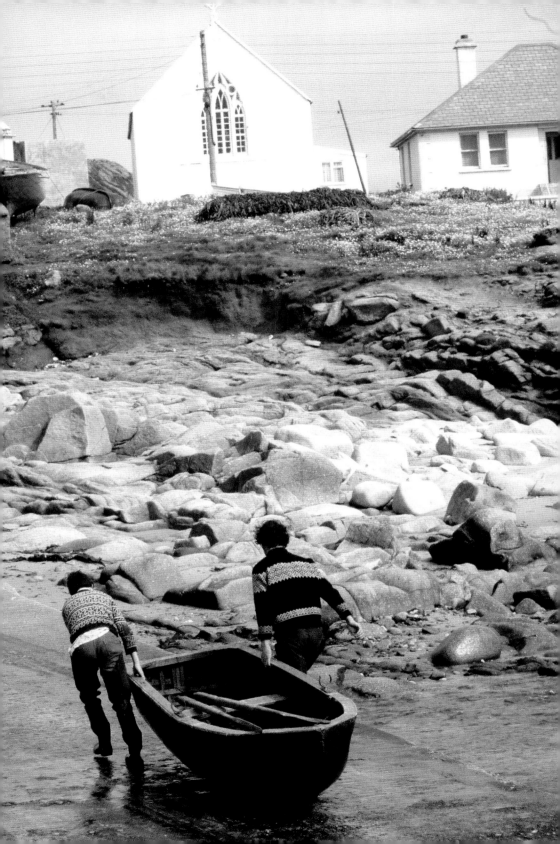

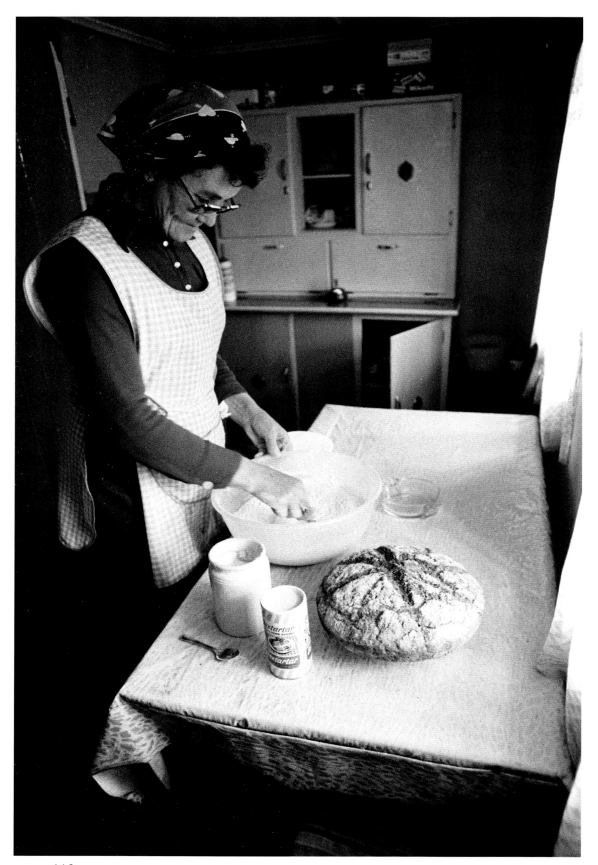

Opposite: Mary Denis baking traditional Tory bread, 1970s.

Below: A working passage to the island – on a boat carrying a load of turf.

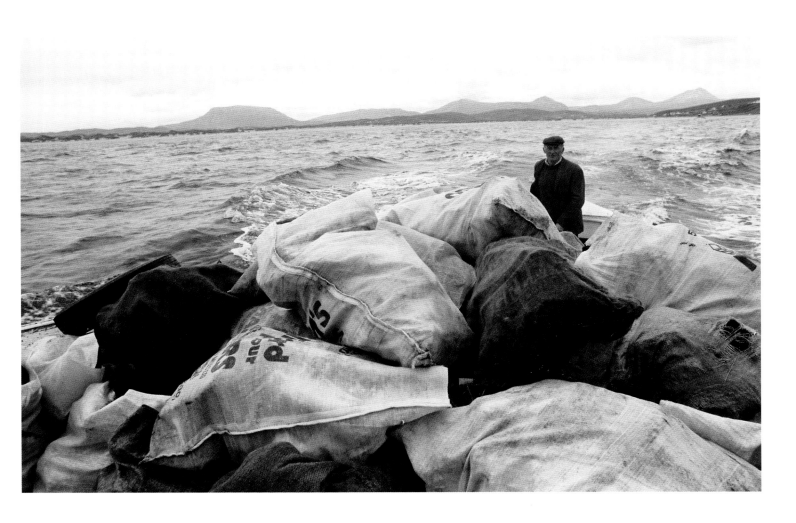

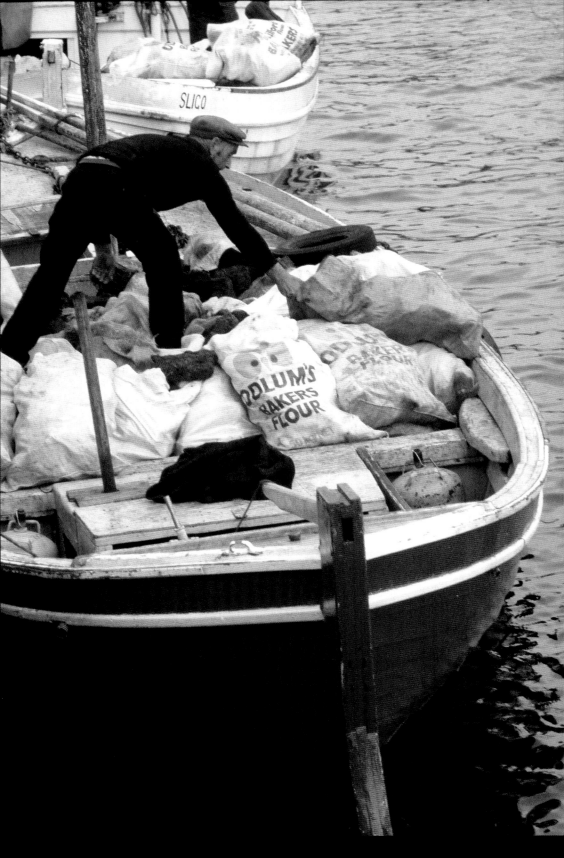

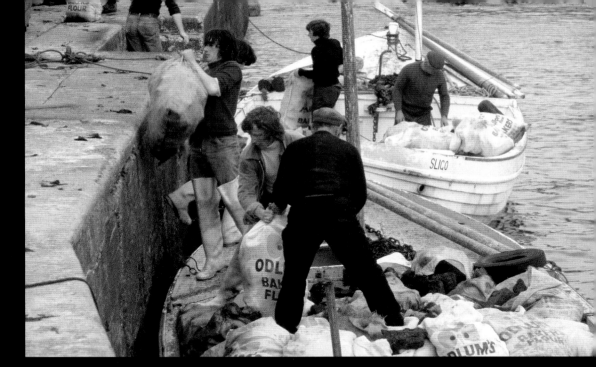

Unloading the valuable turf, essential to keep all the islanders warm over the winter.

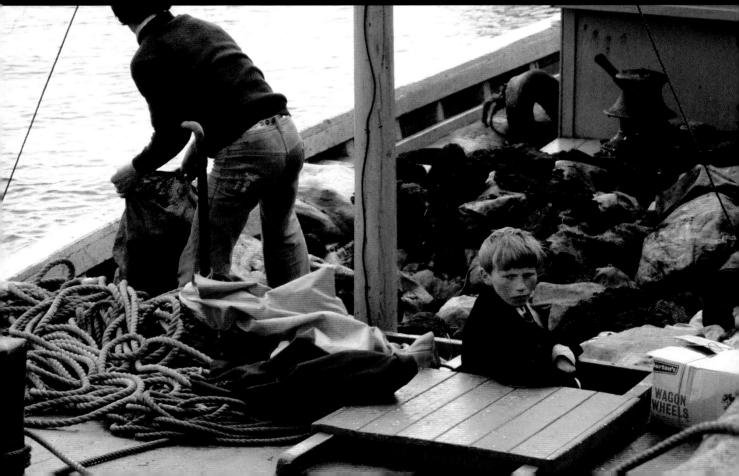

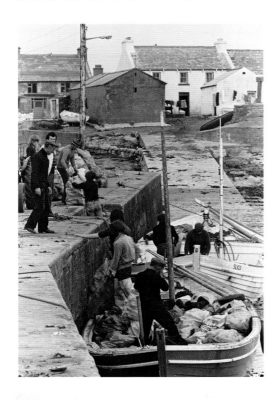

The quayside on Tory Island. Everyone comes to lend a hand, whether tying up a boat or unloading its cargo.

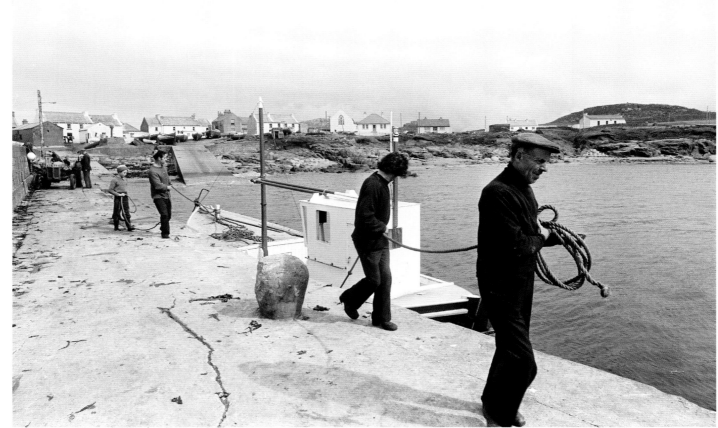

The King of Tory, Patsy
Dan Rodgers.

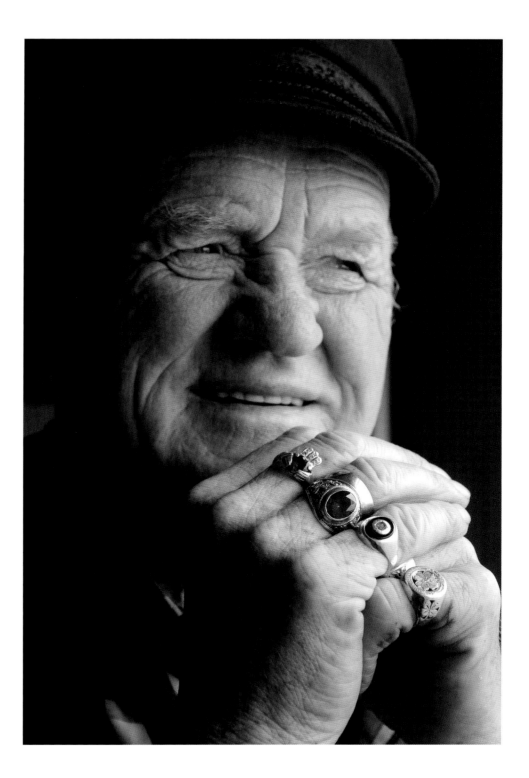

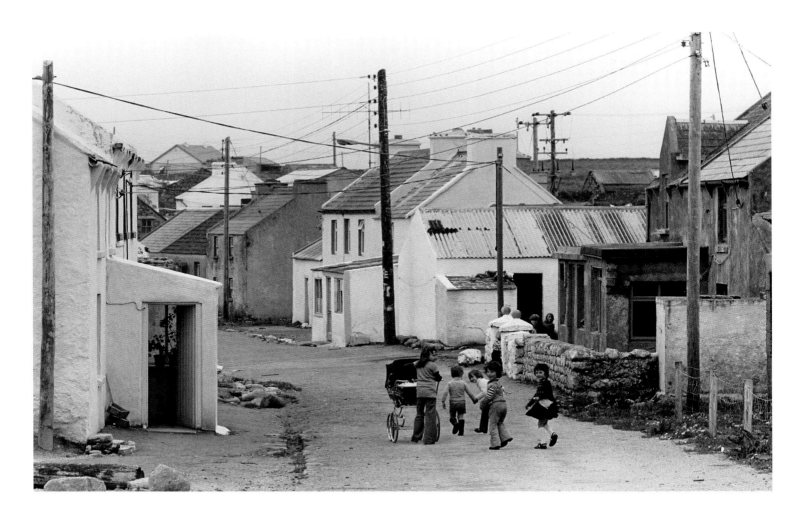

Some of the children of Tory – Margaret Mary Rodgers, Helen Rodgers, Frances Rodgers, Janette Rodgers and Triona Rodgers.

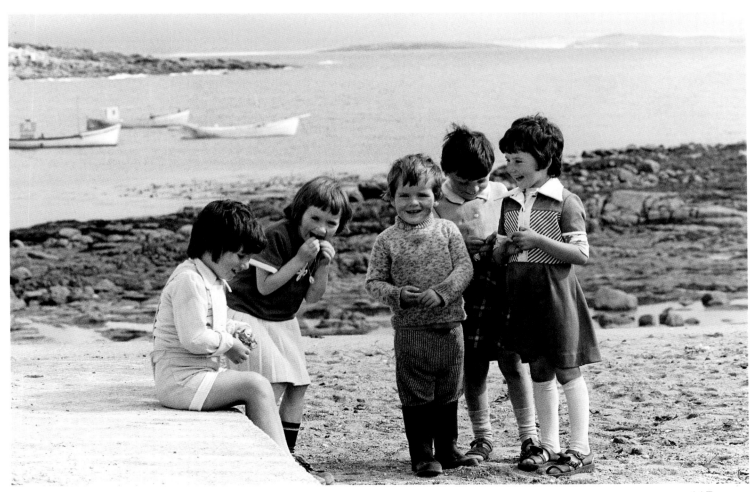

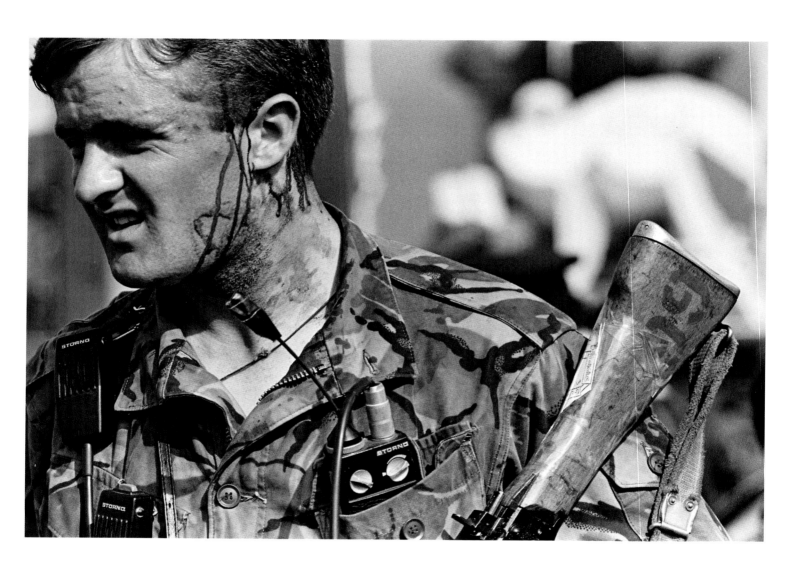

THE NORTH

In 1977, the Queen of England, on her Silver Jubilee, paid a visit to Belfast city centre. Large-scale protests were mounted to coincide with the visit, and soldiers came under attack a few hundred yards away from the royal visitor, shots being fired from the Divis Flats.

I went up with my Press colleague Colman Doyle. This was my first time at any event in the North, though Colman had been covering it for years. Being from the South, I wouldn't have been able to walk up the Shankill Road, but I could walk safely around the Falls Road with no trouble. We stayed on the Falls Road, and didn't cover the Queen at all, but stayed where we were, as we thought the area might be sealed off to contain any disturbances. We worried that if we went outside the area, we wouldn't get back in.

Covering the Troubles was my introduction to the Six Counties. I wish I had taken more photographs during visits to the North around this time, as it has changed so completely. It was another world for a young fella from south Dublin.

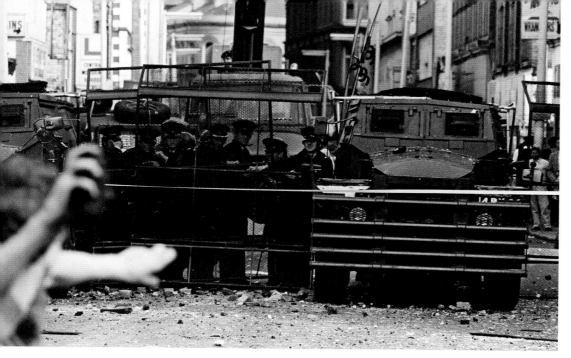

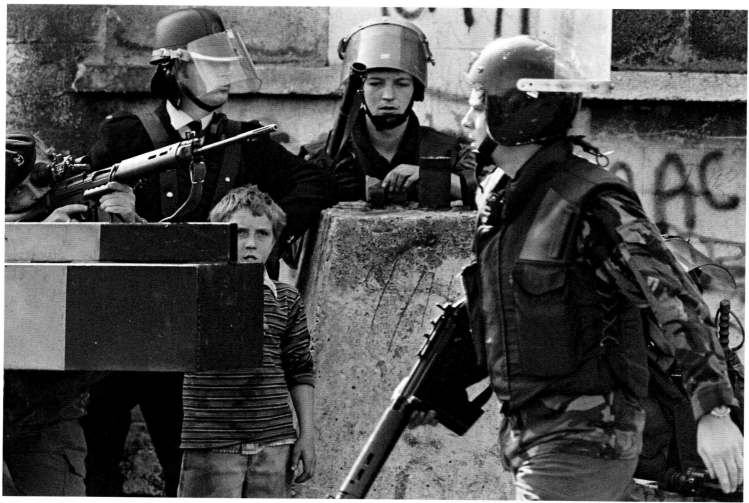

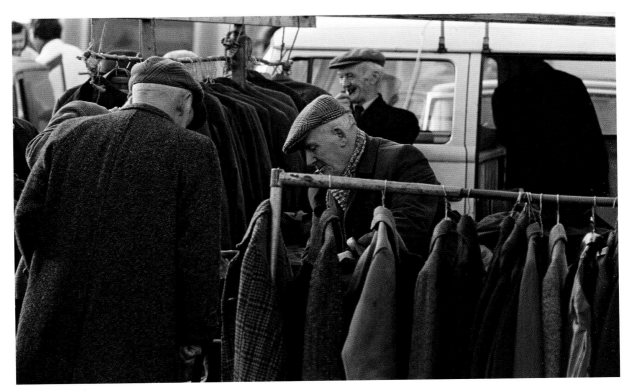

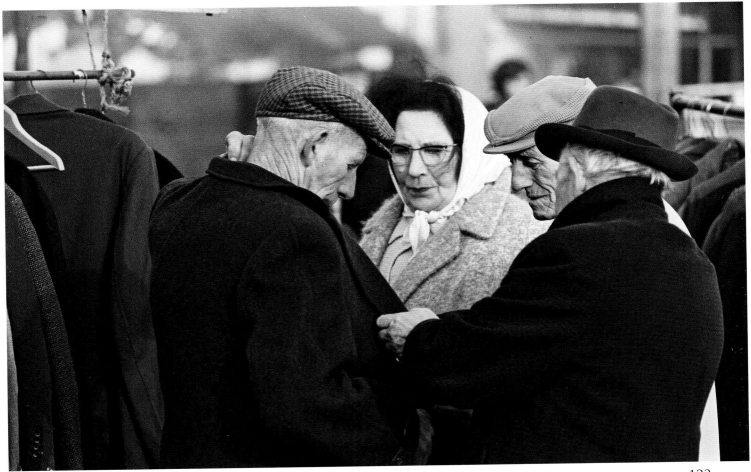

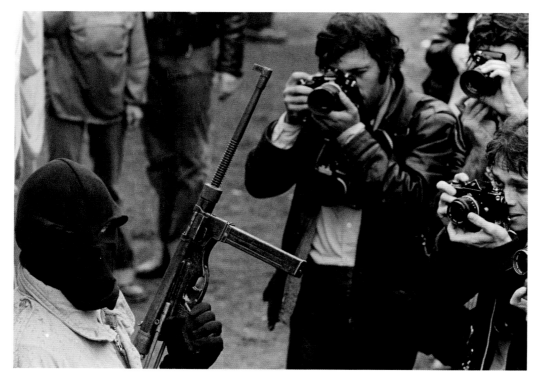

Left: An IRA volunteer poses for the media at a Noraid rally in Belfast, August 1979.

Below: Civil disturbances in Derry, May 1981, following the death of the second hunger striker, Francis Hughes. Eight more young men were to die in the following months.

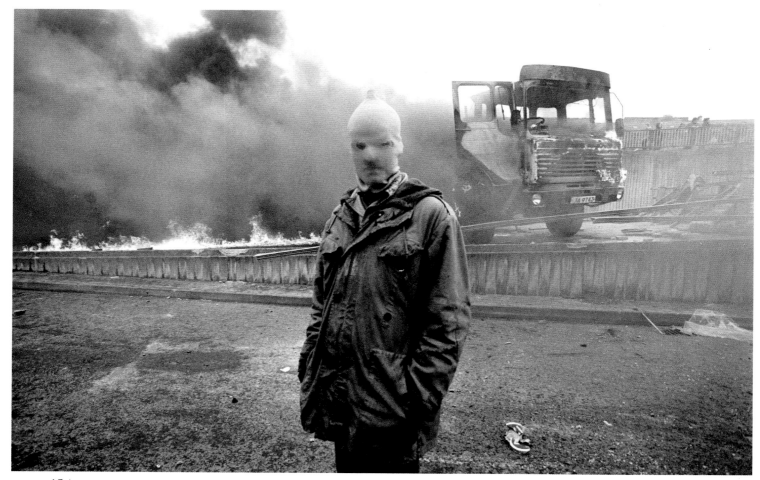

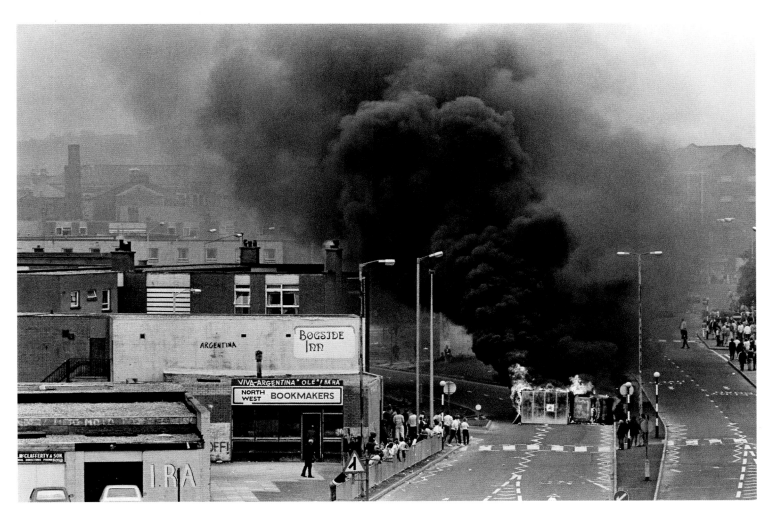

A riot at the Bogside, Derry, during the hunger strikes, 1981.

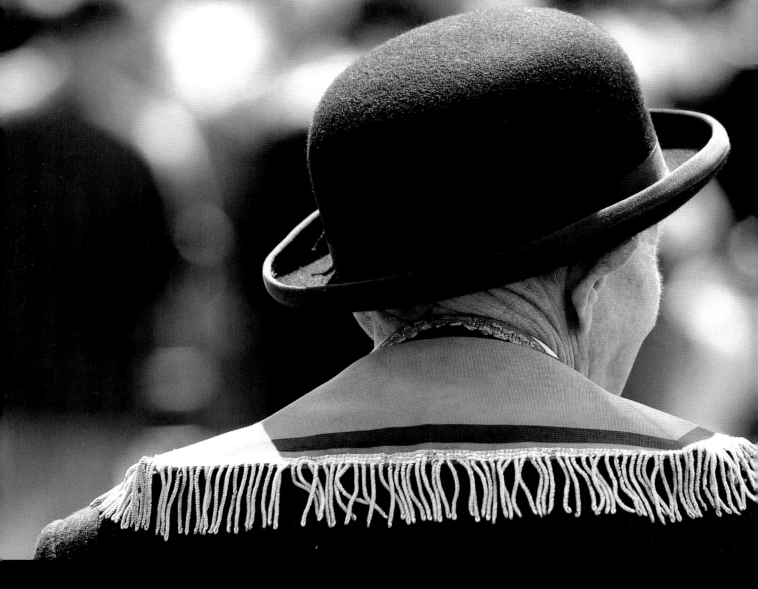

Watching the parade pass by, at the Twelfth of July celebrations at Keady, County Armagh, 2001.

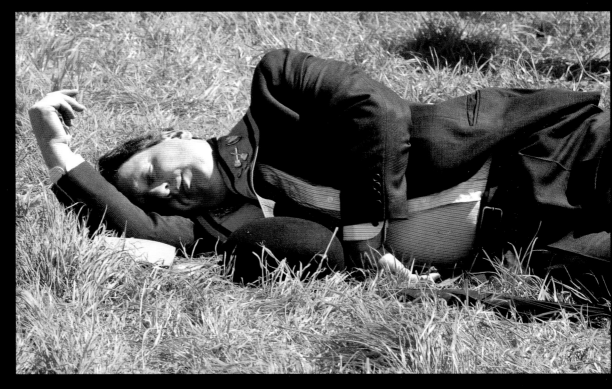

Taking a break from the festivities.

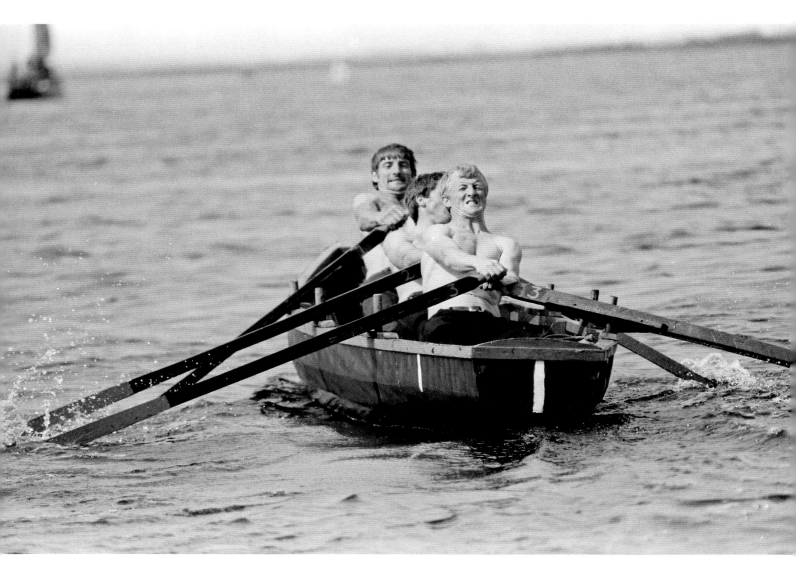

A currach race at Kinvara, in south County Galway.

SPORT

When working in large stadiums around the world, photographers are usually corralled together, and due to restrictions often end up with similar shots. Having covered five Olympic Games, starting with Los Angeles in 1974 and ending up in Sydney for the 2000 Olympics, I felt obliged to include some sports pictures in this publication. Trawling through my old rolls of film from football World Cups to Six Nations rugby matches, I steered away from predictable sports-book fare, and chose some old black-and-white photographs from the more unusual and local sporting activities. These include the highly competitive sports of road bowling, dog racing and currach racing – events that don't normally attract the attention of the major sports agencies. While it truly is a luxury not to be surrounded by other photographers, these sports are also the most fun to photograph.

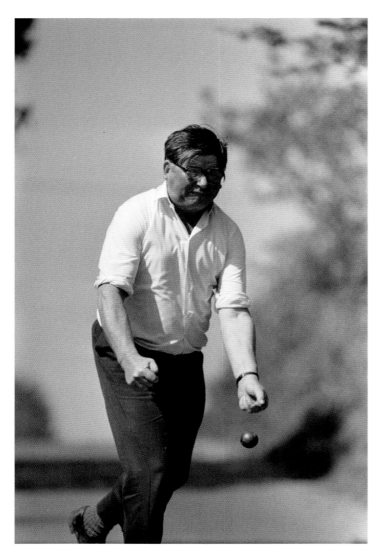

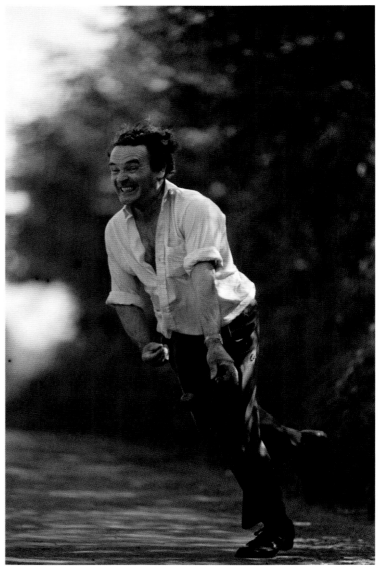

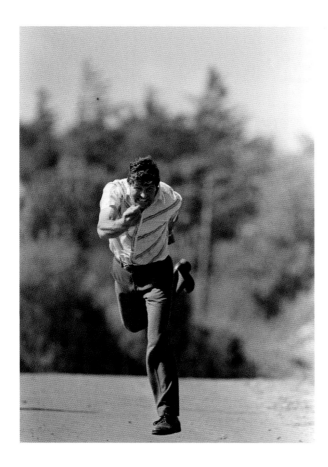

Road bowling, a sport that requires skill as well as great strength.

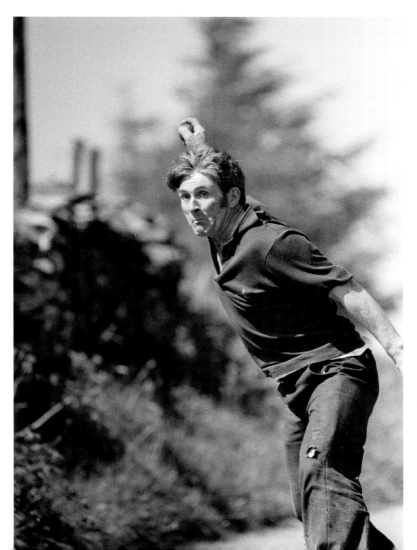

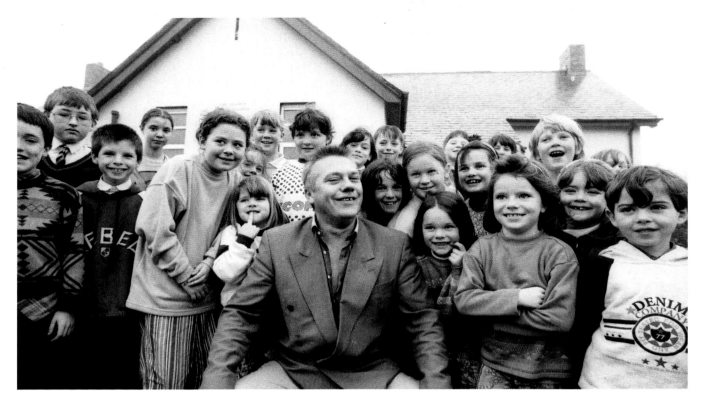

Above: I ran across Páidí Ó Sé on a number of occasions, including wonderful trips to his home town of Ventry, County Kerry. He asked me to take his picture with local children at his old national school, or Alma Mater, to be included in an exhibition of photographs I had in his pub in the town, around 1992. **Below:** It was with great sadness that I ended up photographing his funeral twenty years later, in 2012.

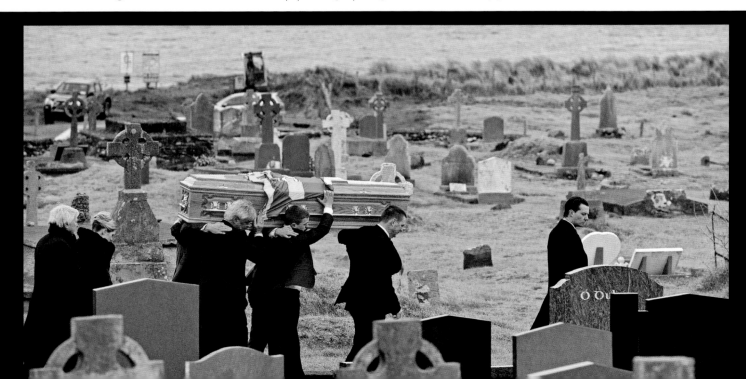

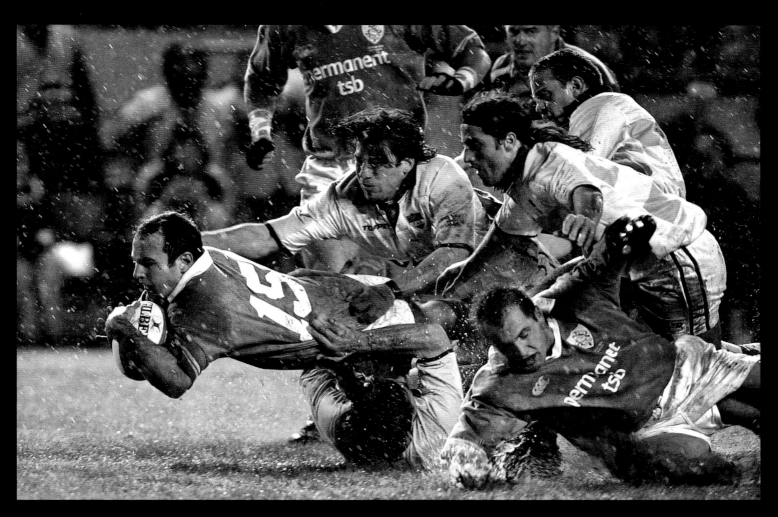

While a certain amount of skill is required to capture international games, sometimes luck also plays a part. On this occasion, the frame I captured, while only milliseconds away from those of my colleagues, became a PPAI award winner. Girvan Dempsey scores a try in the pouring rain at Lansdowne Road, 31 January 2011, as Ireland beat Argentina 16:7.

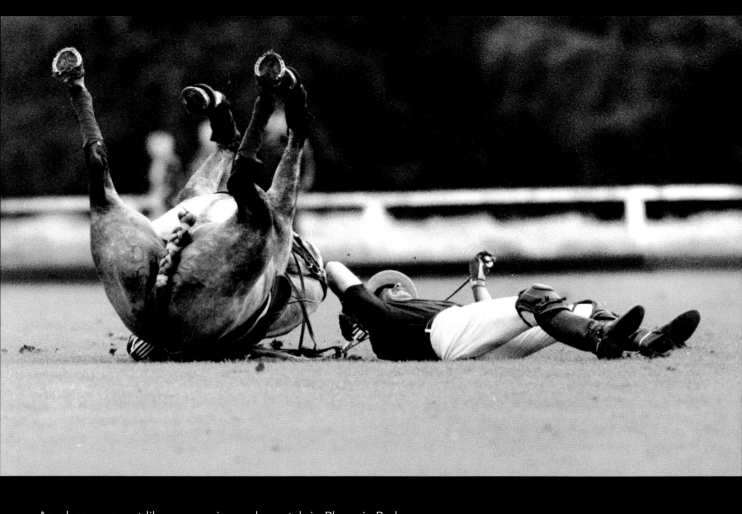

An obscure event like an evening polo match in Phoenix Park
might seem unlikely to produce a once-in-a-lifetime shot. Here
both rider and horse are upended, and the picture brought
the event onto the front page of the *Irish Times*.

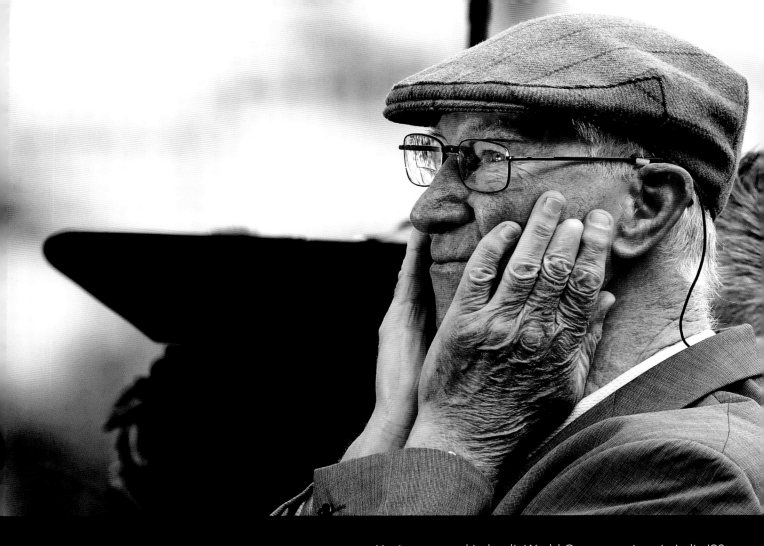

Having covered Ireland's World Cup campaigns in Italia '90 and USA '94, a quarter of a century passed before catching an emotional Jack Charlton in the Aviva stadium. The occasion was Ireland versus England, 7 June 2015. A nil-all

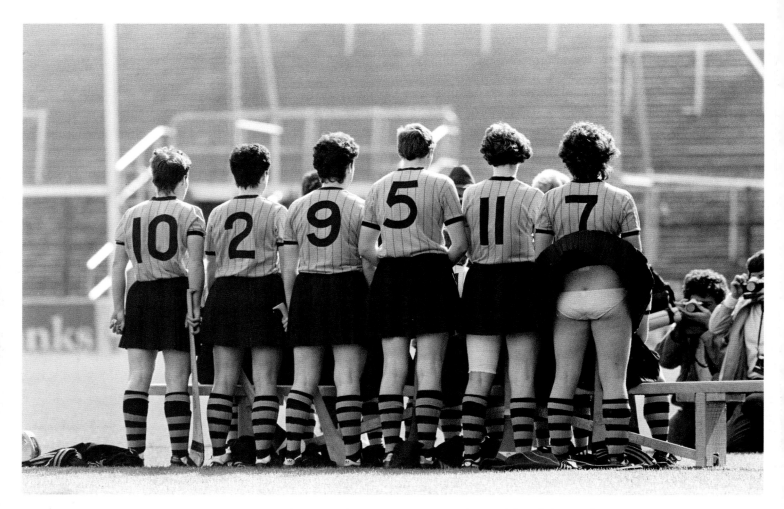

As photographers went out onto the middle of the pitch to record the two teams before the 1989 camogie all-Ireland final at Croke Park, I stayed behind to photograph the photographers. Nature played its part, and a gust of wind elevated the picture from a mundane team portrait into a unique photographic moment. In the event, Kilkenny beat Cork 6-7 to 1-11.

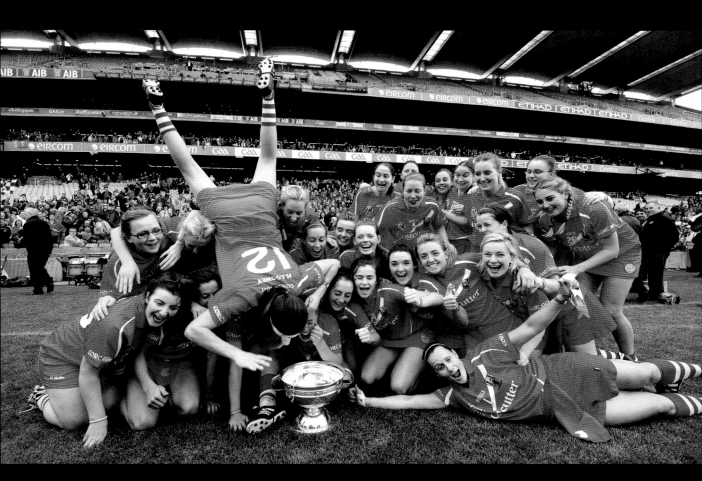

Camogie can be a photographer's

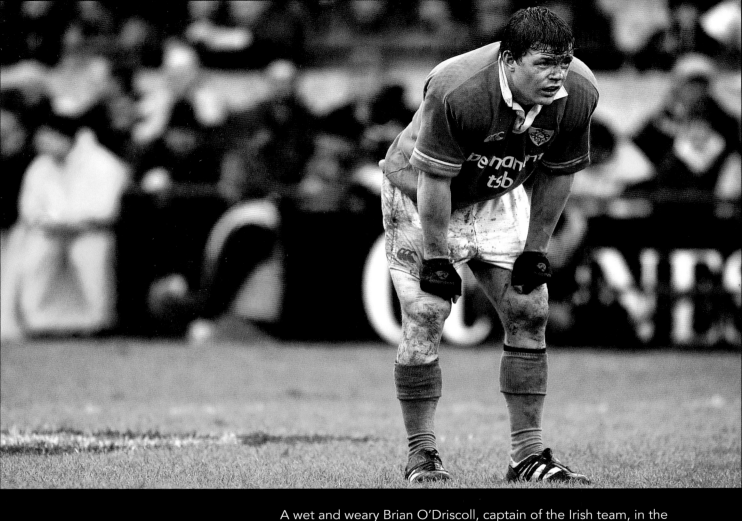

A wet and weary Brian O'Driscoll, captain of the Irish team, in the dying moments of the Six Nations Championship match against France at Lansdowne Road, 2003. Ireland won the match 15-12. The team would eventually go on to meet England, with both sides holding 4-0 records, that match therefore giving a tournament grand slam to one or other side. In the end, it was a decisive 42-6 victory for England.

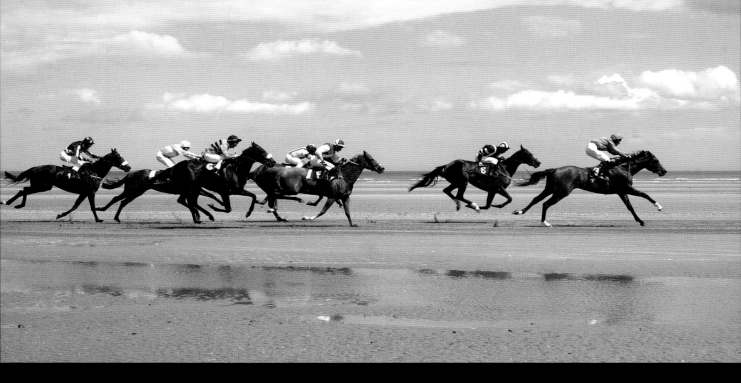

Laytown Strand Races, 2003.

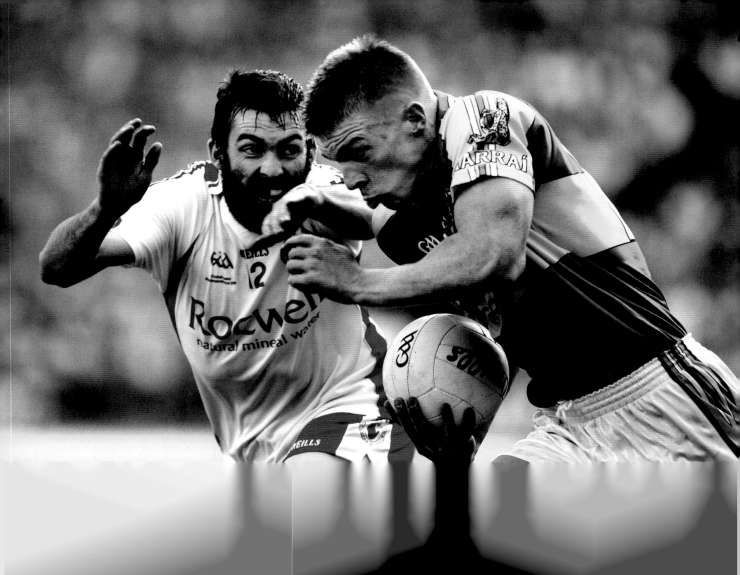

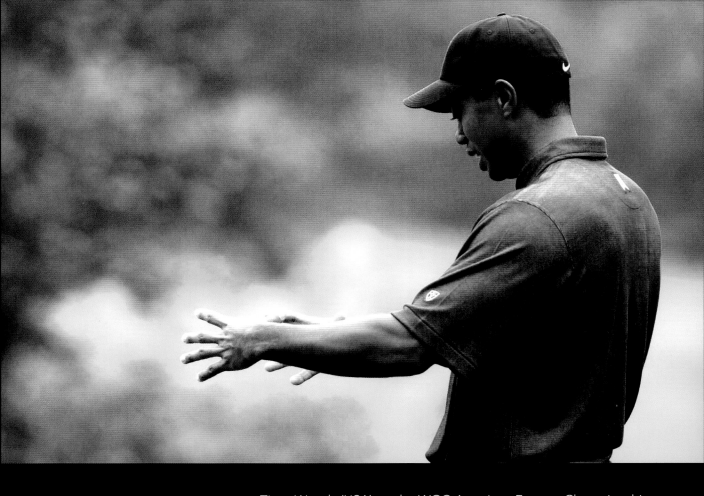

Tiger Woods (USA), at the WGC-American Express Championship at Mount Juliet, 2002. The world's number one golfer at the time, Woods won the competition, his fifth world championship, setting a tournament record of twenty-five under par.

Other books from the O'Brien Press

Ireland in Pictures

Two of Ireland's premier photographers, The Lensmen, captured the essence of life in Ireland over four decades with their stunning and thought-provoking images. These collections offer fascinating insights into the cultural and political events of an era of change in Ireland, in a celebration of a time gone by.

Written and photographed by Carsten Krieger, foreword by Gordon D'Arcy

Ireland's Coast showcases Ireland's landscape, wildlife and people, interspersed with stories and anecdotes compiled over the author's two years of travel. This evocative collection of images of Ireland's coast in all its splendour is perfect for native or visitor.

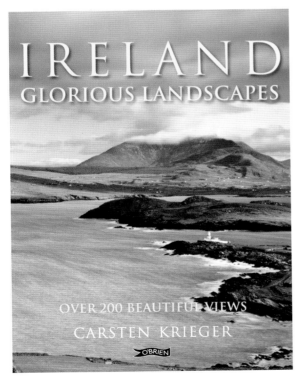

Written and photographed by Carsten Krieger, introduced by Peter Harbison, text by Muriel Bolger

An atmospheric collection of over 200 wonderful photographs showing the beauty and diversity of Ireland's landscape.